IMAGES
of America

LONGMEADOW

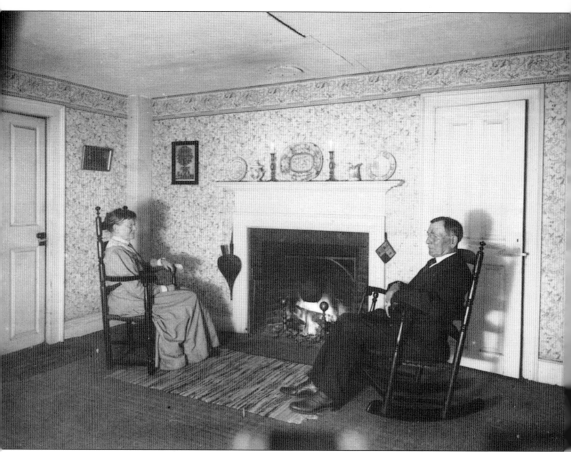

Many of the photographs in the book come from the Emerson Collection of the Longmeadow Historical Society. Paesiello Emerson (1832–1927), pictured here with his half sister Annie Emerson, was a boot maker and a Civil War veteran who took up photography as a retirement hobby in 1900. He willed his collection of more than 1,500 glass-plate negatives to Annie, who later donated them to the Longmeadow Historical Society, of which she was a member. (Longmeadow Historical Society, Paesiello Emerson Collection.)

ON THE COVER: This image, labeled just "Henry and Edna," is thought to portray Henry Emerson (1866–1943) and Edna (likely his niece) sometime around 1910. The Emerson family farmed land at the corner of Longmeadow Street and Depot Road (now renamed Emerson Street in their honor). The property was originally granted to Josiah Cooley, who in 1760 built the house still standing today at 476 Longmeadow Street. Paesiello Emerson, Henry's older half brother, took the photograph. (Longmeadow Historical Society, Paesiello Emerson Collection.)

IMAGES
of America

LONGMEADOW

Thomas L. Higgins

ARCADIA
PUBLISHING

Published by Arcadia Publishing
Charleston, South Carolina

Printed in the United States of America

Library of Congress Control Number: 2017963599

For all general information, please contact Arcadia Publishing:
Telephone 843-853-2070
Fax 843-853-0044
E-mail sales@arcadiapublishing.com
For customer service and orders:
Toll-Free 1-888-313-2665

Visit us on the Internet at www.arcadiapublishing.com

*Dedicated to my parents, Louis J. and Mary A. Higgins;
published historians themselves, they taught me to
look to the future while respecting the past.*

CONTENTS

ACKNOWLEDGMENTS

Assembling a photographic history is far easier when true historians have already done the heavy lifting of poring over old documents and assembling timelines. I owe a debt of gratitude to those who built the scaffolding that we all might have a better view. Prof. Richard S. Storrs (1830–1884) with colleagues J.W. Harding and Oliver Wolcott created *Proceedings at the Centennial Celebration of the Incorporation of the Town of Longmeadow* (Town of Longmeadow, 1884) for the town's 1883 centennial celebration. Linda M. Rodger and Mary S. Rogeness, long-standing members of the Longmeadow Historical Society, produced the outstanding *Reflections of Longmeadow 1783/1983* for the town's bicentennial celebration. The Longmeadow Historical Society's Through the Lens: Longmeadow 100 Years Ago, published weekly in the *Longmeadow News*, and its official publication *Town Crier* have both been invaluable (available at www.longmeadowhistoricalsociety.org). Several details came from "Betsy's Corner" blogs, written by Betsy Huber Port, former secretary of the Longmeadow Historical Society.

I am gratified by the outpouring of support from the Longmeadow community for this project. The Longmeadow Historical Society has graciously given me access to its extensive files and images. Particular thanks are extended to Beth Hoff, Al and Betsy McKee, and Jim Moran, who spent considerable time answering queries and locating and helping me scan images. Maggie Humberston at the Lyman & Merrie Wood Museum of Springfield History, Tony Zampicenti of the East Longmeadow Historical Society, and fellow Arcadia authors Jack Hess (*East Longmeadow*) and James Malley (*Enfield*) shared photographs and perspective. Barbara Fitzgerald at the Richard S. Storrs Library; Mike Moran at Bay Path University; Rick McCullough Jr. of R.A. McCullough builders; Charlie D'Amour, Claire D'Amour-Daley, and Jonathan Wilson at Big Y Foods; Rod Clement at the Longmeadow Country Club; Greg Lamb at the Longmeadow Fire Department; and Sgt. Andy Fullerton of the Longmeadow Police Department all provided previously unpublished images. Thanks also go to Steven Weiss at the Longmeadow Historical Commission, Carol Daigle at Longmeadow High School, and the librarian at Sinai Temple (who requested anonymity). Most of all, thanks go to my lovely wife, Suzanne Higgins, for helping to choose photographs, proofreading text, and ongoing support of my passion for history!

A subset of the Longmeadow Historical Society's archive, the Paesiello Emerson Collection, and the Bay Path University collection are both available online through Digital Commonwealth at www.digitalcommonwealth.org.

INTRODUCTION

In 1636, an expedition led by William Pynchon of the Massachusetts Bay Company travelled up the Connecticut River from Long Island Sound to establish a trading post. Favorable trade possibilities were envisioned where the Agawam (now Westfield) and Chikuppe (now Chicopee) Rivers joined the Connecticut River; there was also suitable land for farming, grazing and trapping. The Agawam Indians, primarily hunters and fishermen, called the floodplain along the river Masacksic, which the English translated as "the long meddowe." Decimated just a few years earlier by smallpox carried by European explorers, the Agawams traded away three tracts of land: the west side of the Connecticut River (today's West Springfield and Agawam); the east side of the river from Pecousic Brook north to the Chikuppe River (today's Springfield and Chicopee); and Masacksic (today's Longmeadow). The agreement signed by Pynchon, Henry Smith, and John Burr in 1636 allowed the Natives to continue to hunt and grow crops on the long meddowe. While the long meddowe was initially intended as shared common pasture for settlers who resided in Springfield, by 1645, specific lots were being granted to attract settlers; the first house appeared about 1649. By 1661, the Bay Path Trail connected the meadows to Springfield close to the alignment of today's Interstate 91. The early settlers did not realize what the Natives knew: the meadows were subject to periodic flooding of the Connecticut River. Although the flood of 1695 was one of many, and not even the worst, it was the impetus to ask permission (granted in 1703) to move the settlement a half mile east to the bluff overlooking the meadows. The early homes on the meadows were primitive saltbox designs with thatched roofs. Although legend suggests some entire homes were dragged up the hill, it is considered more likely that timbers were salvaged from early dwellings to build new structures (animal pens, barns, and eventually houses) on either side of the Country Road, today's Longmeadow Street. The first dwellings were small, only later being supplanted by the Georgian-style homes that grace Longmeadow Street today.

Seventeenth-century residents still had to travel to Springfield for church services. In the spring of 1676, the John Keep family, on their way to have their infant Jabez baptized, became some of the last victims of King Philip's War, which had started earlier near the Plymouth Colony south of Boston. Relationships between the English settlers and Native Americans, some of whom were allied with the rival colonial French in New France (then extending from Canada through the Great Lakes to Louisiana), were uneasy for nearly a century. In 1713, the growth of the settlement led to approval of Longmeadow as a precinct of Springfield, a designation by the Massachusetts General Court permitting the town to have its own minister and meetinghouse. The precinct was bounded by Pecousic Brook (now Porter Brook and Porter Lake in Forest Park) to the north, the Connecticut River to the west, a fluctuating southern border with the town of Enfield, and to the east by "province lands" (those not belonging to a particular town). This land today hosts East Longmeadow and parts of Wilbraham and Hampden. The town gained land from Enfield, Connecticut, in 1684 but ceded acreage to Springfield during the creation of Forest Park in 1890 and Franconia in 1914.

Longmeadow was officially incorporated on October 17, 1783. Though primarily a farming community, Longmeadow also had tanners, shopkeepers, and even manufacturers of buttons and pistols. Quarries in the eastern part of the town (today's East Longmeadow) provided Longmeadow brownstone, prized for lintels and trim in countless public buildings and New York City brownstones. The Bay Path Trail (later the northern branch of the Boston Post Road) passed through Longmeadow, forming a major land route between Colonial New York and Boston via New Haven, Hartford, and Springfield. Railroads arrived with the Connecticut River Railroad in the west village in 1844 and the New London, Willimantic & Springfield Railroad in the east village by 1875. Springfield was the junction for trains to Boston and Albany as well as north through the valley to Northampton, Greenfield, Vermont, and Montreal. The transition from farming community to streetcar suburb was driven by the arrival of electrified trolley lines beginning in 1896, tripling the population. A second wave of suburban development occurred after World War II, accelerated by the completion of Interstate 91 in 1958.

Today, Longmeadow is home to nearly 16,000 people with a population of 1,731 per square mile (668.3 per square kilometer). Despite the population density, much of the town is permanent open space, including the Donald Ross–designed Longmeadow Country Club, the Twin Hills, part of the Franconia golf courses, large and small public parks, and the extensive Fannie Stebbins Wildlife Refuge along the Connecticut River. It is a photogenic community with some 100 houses built before 1900 and a historic town green. The town is recognized for its excellent public and private schools and is also home to Bay Path University. Notable residents have included John Chapman (Johnny Appleseed), cartographer J.H. Colton, dental pioneer Nathan Cooley Keep, former Massachusetts governor Foster Furcolo, and celebrities Aaron Lewis of the band Staind, writer Anita Shreve, NFL coach Joe Philbin, actress Bridget Moynahan, and actor John Deluca.

Longmeadow's rich history has been documented in many photographs, especially the work of Paesiello Emerson, who between 1900 and his passing in 1927 took over 1,600 images, the vast majority of them in his adopted hometown. Rounding out the story are photographs preserved by individuals and organizations in the area. There are too many great images to present in a single book, but I hope that those I have selected bring back memories to some and frame today's Longmeadow via the events of the past.

One

FROM ANTIQUITY TO THE REVOLUTION

Native Americans of the Algonquian-speaking Pocomtuc confederacy occupied much of the Connecticut (Quinneckiot, or "long") River valley north of the Enfield Falls as far as Deerfield, Massachusetts. The Agawam tribe of the Pocomtucs lived along the Connecticut River near the confluence of the Agawam (now Westfield) and Connecticut Rivers. The river and its tributaries offered trade routes, along with the Bay Path Trail (today's US Route 20) to Boston, capital of the Massachusetts Bay settlement. This 1903 photograph, aside from the few houses in the distance, shows how the preindustrial era may have looked. (Longmeadow Historical Society, Paesiello Emerson Collection.)

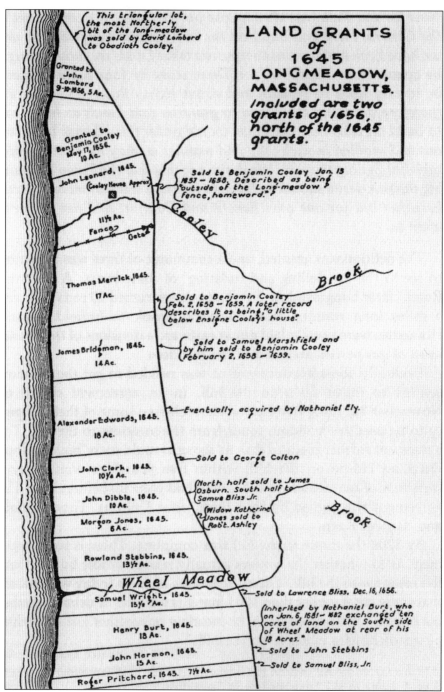

This triangular lot, the most Northerly bit of the long-meadow was sold by David Lombard to Obadioth Cooley.

Granted to John Lombard 9-12-1656, 5 Ac.

Granted to Benjamin Cooley May 17, 1656. 10 Ac.

LAND GRANTS
of
1645
LONGMEADOW,
MASSACHUSETTS.
Included are two grants of 1656, north of the 1645 grants.

John Leonard, 1645.
(Cooley House Approx.)

Sold to Benjamin Cooley Jan. 13 1657 – 1658. Described as being "outside of the Long-meadow fence, homeward."

Cooley

Brook

11½ Ac.
Fence
Gate

Thomas Merrick, 1845.
17 Ac.

Sold to Benjamin Cooley Feb. 2, 1658 – 1659. A later record describes it as being "a little below Ensigne Cooley's house."

James Bridgman, 1645.
14 Ac.

Sold to Samuel Marshfield and by him sold to Benjamin Cooley February 2, 1658 – 1659.

Alexander Edwards, 1645.
18 Ac.

Eventually acquired by Nathaniel Ely.

John Clark, 1645.
10½ Ac.

Sold to George Colton

John Dibble, 1645.
10 Ac.

North half sold to James Osburn. South half to Samuel Bliss Jr.

Morgon Jones, 1645.
6 Ac.

Widow Katherine Jones sold to Rob't. Ashley.

Brook

Rowland Stebbins, 1645.
13½ Ac.

Wheel Meadow

Samuel Wright, 1845.
15½ Ac.

Sold to Lawrence Bliss, Dec. 16, 1656.

Henry Burt, 1845.
18 Ac.

Inherited by Nathaniel Burt, who on Jan. 6, 1681 – 1682 exchanged ten acres of land on the South side of Wheel Meadow at rear of his 18 Acres."

John Harmon, 1645.
15 Ac.

Sold to John Stebbins

Roger Pritchard, 1645. 7½ Ac.

Sold to Samuel Bliss, Jr.

A smallpox epidemic in 1633–1634 decimated the Agawam population from an estimated 1,200–1,900 to fewer than 200. In 1636, Springfield founder William Pynchon purchased land on both sides of the river from the Agawams. This 1940 map drawn by Harry Andrew Wright shows the land grants of 1645. Many names are still familiar today: Benjamin Cooley, a skilled weaver, owned the land around the brook that bears his name. Keep, Burt, Colton, and Bliss are prominent names in Springfield and Longmeadow history. (Longmeadow Historical Society.)

10

This figure continues the map from the prior page south to present-day Longmeadow Brook, which runs through the meadows north of Bark Haul Road. Raspberry Brook and the land south to the Enfield border are not pictured. Originally, Longmeadow Brook did not directly enter the Connecticut River. Instead, it combined with Raspberry Brook to the south. Speculation is that a ditch was dug at the south end of the mill lot, creating the brook's present course. (Longmeadow Historical Society.)

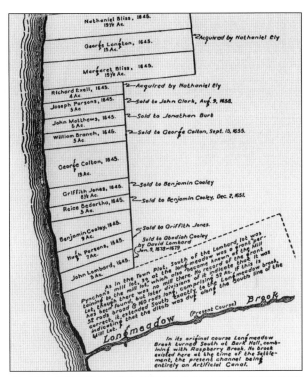

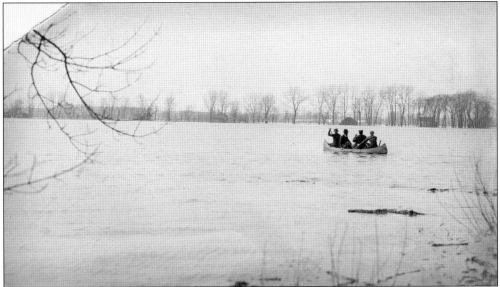

The Connecticut River is the longest river in New England; its northernmost headwaters define the international boundary with Quebec, Canada. Forming the border between New Hampshire and Vermont, the river divides western Massachusetts and Connecticut on its way to Long Island Sound. With its large watershed, heavy winter snowfall and an early spring thaw periodically causes the Connecticut to overflow its banks. A 1695 flood forced the initial settlement to the bluff overlooking the river. This photograph documents another flood in 1913; the river is beyond the tree line, and the canoe is in the vicinity of today's Interstate 91. (Longmeadow Historical Society.)

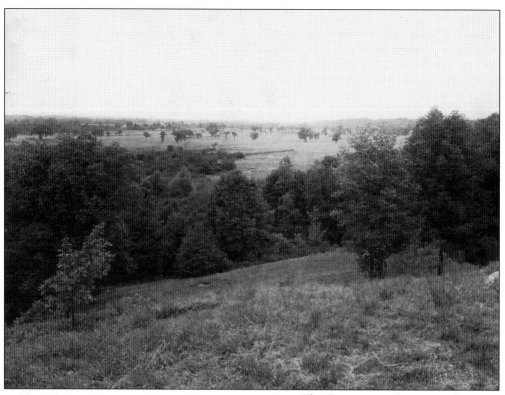

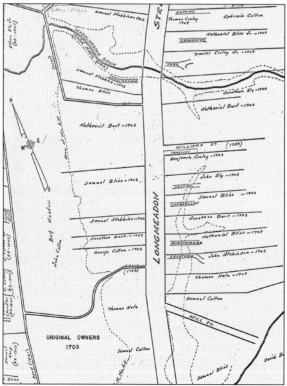

The Connecticut River is widest (about 2,100 feet, or 640 meters) between Longmeadow and the Six Flags New England park in Agawam. Roughly a mile from the river, the land rises up from the floodplain, as seen in this 1933 photograph from Spark's Bluff. The Agawams called the floodplain Masacksic, or "long meadow." (Longmeadow Historical Society, Paesiello Emerson Collection.)

In 1703, the original property owners were granted permission by the Town of Springfield to relocate the settlement from the meadow onto higher ground to the east. Bliss, Burt, Colton, Cooley, Keep, and Stebbins were among the original inhabitants of the meadows. The dotted lines illustrate the change in elevation at the brow of the hill and along various brooks. (Longmeadow Historical Society.)

On February 29, 1704, French and Native American forces attacked the frontier village of Deerfield, burning part of the town, killing 47 settlers, and taking the remaining 112 citizens north to New France (Quebec). Minister John Williams and his surviving family members, including his 10-year-old son Stephen and eight-year-old daughter Eunice, were taken hostage. All except Eunice were eventually "redeemed." This portrait shows Stephen Williams (1693–1782), who graduated from Harvard College in 1713, wrote the best-selling memoir *Boy Captive of Deerfield*, and came to Longmeadow in 1714, two years before his ordination as a minister. (Longmeadow Historical Society.)

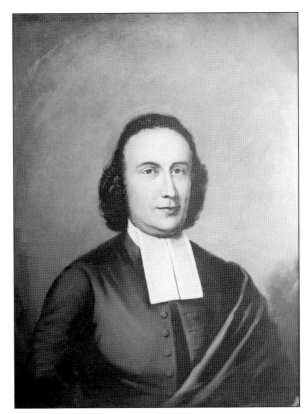

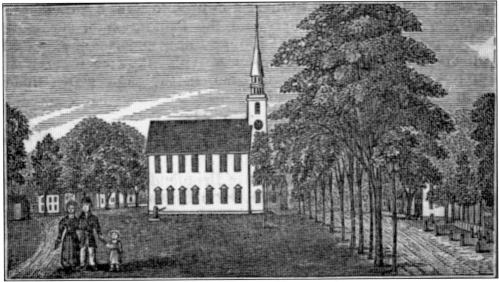

Longmeadow's first meetinghouse was constructed in the center on the green in 1716. By 1764, the small structure (32 by 38 feet) became inadequate; the second meetinghouse was constructed in 1767–1768 just north of the original church. The earliest known image is this 1839 engraving by John Warner Barber (1798–1885) of East Windsor, Connecticut. Stephen Williams, DD, Longmeadow's first minister, built a home nearby at the site of today's Longmeadow Community House. (Longmeadow Historical Society.)

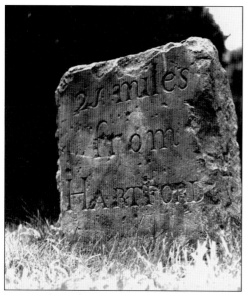

In the early Colonial era, transport between major cities was by sea; land routes were dangerous and difficult to navigate. By 1633, Massachusetts Bay settlers used two primary routes based on Native trails. The coastal trail (today's US 1) connected Boston via Providence and New Haven to New York City. The Bay Path Trail headed west from Boston to Springfield (today's US 20 route), turning south to follow the Connecticut River through Hartford to New Haven (today's US 5 route). This became the northern, or inland, branch of the Boston Post Road in the early 1700s. Two mile markers, thought to date from 1706, survive in Longmeadow. The one indicating 21 miles from Hartford is near 1206 Longmeadow Street, and the nearly illegible 22-mile marker is across from the Storrs Library. (Longmeadow Historical Society.)

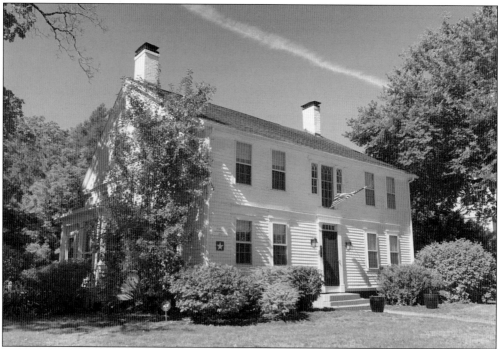

When a horseback journey from New York City to Boston could take a fortnight, taverns were important way stations. With post riders making regular stops, taverns became information centers, often with newspaper publishers on the premises or nearby. Early Revolutionary thought, particularly opposition to the Stamp Act, developed in taverns along the Boston Post Road. By 1824, road improvements reduced travel time by stagecoach between New York and Boston to 36 hours. By the mid-19th century, railroads bypassed the taverns altogether. The White Tavern was built in 1713 or earlier as Nathanial Bliss's home; in 1786, David White purchased it and opened a tavern. It has also been a temporary schoolhouse, a boardinghouse for workers at the Chandler Button Factory, and now again a private residence. (Author's collection.)

Simon Colton, grandson of early settler "Quartermaster" George Colton and the son of John Colton, built this homestead in 1735. It is the oldest complete home in Longmeadow and one of few remaining saltbox-style homes from that era. Maj. Luther Colton (1756–1803), Simon's son, added to the south side of the house. Colton descendants occupied the home for most of its existence. In 1935, the Old Red House was donated to the Society for the Preservation of New England Antiquities (SPNEA). While it is again a private residence, terms of the sale agreement from SPNEA require the front facade and color remain unchanged. (Longmeadow Historical Society.)

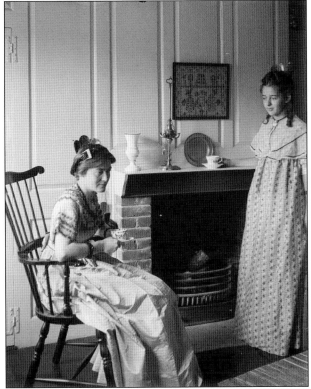

The Old Red House features a 14-foot-square central chimney with a deep beehive oven and five fireplaces. Paesiello Emerson captured two unidentified women in period garb, likely for a historical reenactment, in front of the kitchen fireplace in this undated early-20th-century photograph. (Longmeadow Historical Society, Paesiello Emerson Collection.)

This late-19th-century image shows Longmeadow Street at the corner of Ely Road across from the Storrs Library. On the left is the Ebenezer Bliss house, built in 1720. The home was built with a large center chimney, and during a subsequent reconstruction, two smaller chimneys were added, along with newer rooms to the front of the house. The 1780s house partly visible to the right was the Boies homestead at the time of the picture, but it is now known as the Old Nathaniel Ely House. (Longmeadow Historical Society.)

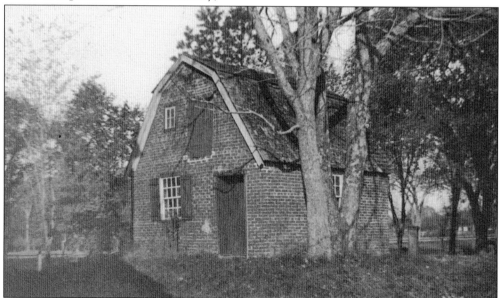

Samuel Colton Booth lived at 577 Longmeadow Street in a house that he built in 1821 just north of Wheelmeadow Brook. His daughter, Mary Allard Booth (1843–1922), was born there and became a prominent photomicroscopist credited with work on eliminating the bubonic plague. Reportedly, this barn on the property, built in 1750, was once used to make brooms. (Longmeadow Historical Society.)

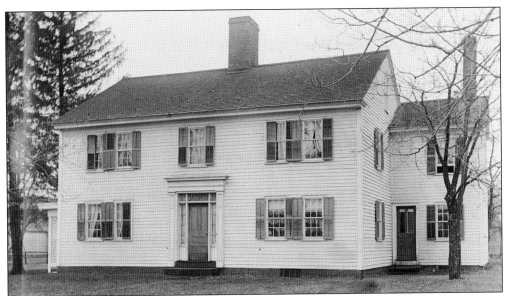

Reusing the foundation of a 1728 home destroyed by lightning in 1749, Josiah Cooley (1716–1778) built this home at 476 Longmeadow Street in 1760. Josiah served in the Revolutionary War, marching to Lexington and Concord. Cooley descendants occupied the home until 1869. The home is pictured in 1924. (Longmeadow Historical Society, Paesiello Emerson Collection.)

Schoolteacher and town historian Annie Emerson, half sister of photographer Paesiello Emerson, lived in the Cooley-Emerson home from 1872 until her death in 1941. Paesiello Emerson captured the south parlor of his half sister's home in 1920. Annie later donated Paesiello's glass-plate negatives to the Longmeadow Historical Society; many of those images are featured in this book. (Longmeadow Historical Society, Paesiello Emerson Collection.)

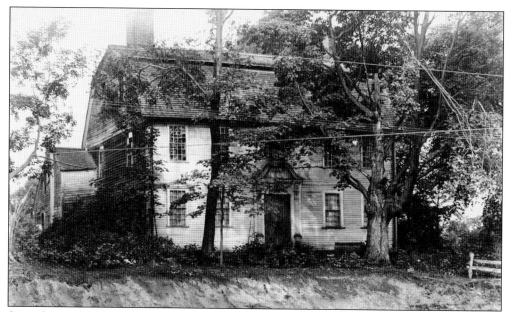

Samuel "Marchant" Colton was a shipbuilder and prominent figure in Longmeadow history. Tax rolls between 1761 and 1775 identify him as the richest man in the precinct. The "Marchant" title refers to his role selling hardware, fabrics, spices, and other goods from a shop behind his home. Although this house was torn down in 1916, the doorway now resides at the Museum of Fine Arts, Boston, as example of fine Colonial architecture. (Longmeadow Historical Society, Paesiello Emerson Collection.)

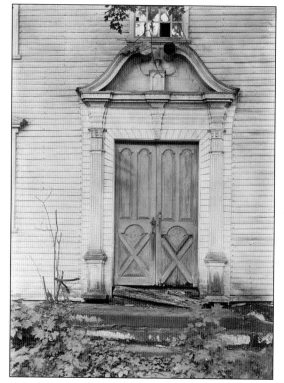

The doorway of the Samuel Colton home was typical of finer homes built in the Connecticut Valley during the first half of the 18th century: two narrow matching doors with an X design below and a symmetrical, broken scroll pediment above. The design is credited to Oliver Eason and Paramenas King of Connecticut, along with Longmeadow joiner John Steel Jr. All three craftsmen worked up and down the Connecticut Valley, likely accounting, with others, for the distinct and unique style of doorways in the region. (Longmeadow Historical Society, Paesiello Emerson Collection.)

Two

First Daughter of Massachusetts

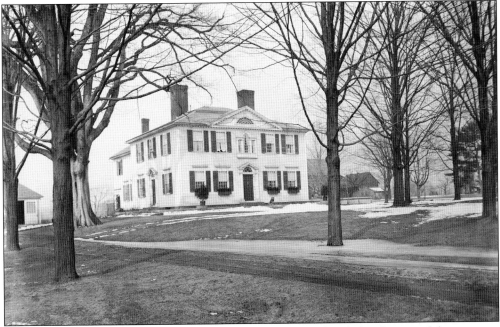

Alexander Field built this late Georgian–style house in 1791; detailed architectural drawings are preserved in the Library of Congress. Given its proportions and symmetry, the house has long been a favorite of students of architecture. The Revolutionary War ended in September 1783 with the signing of the Treaty of Paris. One month later, the general court of the newly independent Commonwealth of Massachusetts approved the incorporation of the town of Longmeadow, which, as the first town created after the Revolution, is credited as "The Oldest Daughter of the Commonwealth." (Longmeadow Historical Society, Paesiello Emerson Collection.)

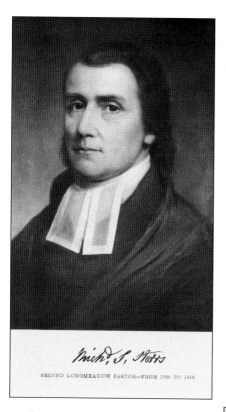

The second permanent pastor of the First Church was Richard Salter Storrs, who arrived in 1785. He succeeded the Reverend Stephen Williams, who died in 1782 after 66 years as pastor. Storrs served for 34 years before falling victim to a local epidemic, dying at age 55 in 1819. The Storrs parsonage, where his 10 children were born, is today headquarters for the Longmeadow Historical Society. (Longmeadow Historical Society.)

The Storrs parsonage was built in 1786; three generations of the family lived in the house. Richard Salter Storrs III and his sister Sarah Storrs donated the property in 1907 for a library. The Longmeadow Historical Society, organized in 1899, purchased the home's contents in 1911. Richard Salter Storrs's second wife was Stephen Williams's granddaughter, so many artifacts came from both families. In 1932, the Storrs House was moved south from its original site to provide room for the current library. (Author's collection.)

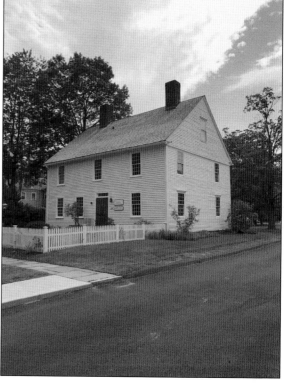

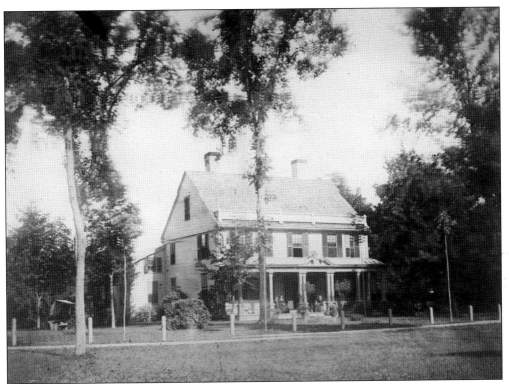

The Storrs House has been restored to represent its original, austere 18th-century condition. This late-19th-century photograph demonstrates that it once had a kitchen "ell" on the northeast corner and was adorned with window shutters, a front porch, and decorative roof railings, all since removed. (Longmeadow Historical Society.)

As with most properties of the pre-automobile era, the Storrs property had a barn to house horses and carriages. The open barn doors reveal a parked surrey; to the left are a horse, its handler, and an open carriage. This site is today occupied by storage facilities for the Storrs Library. (Longmeadow Historical Society.)

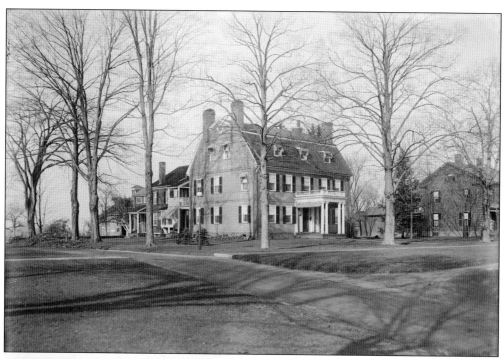

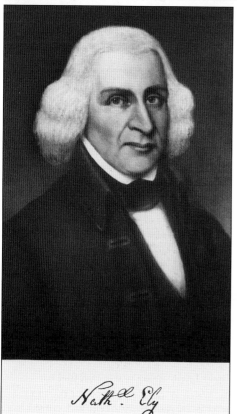

The Old Nathaniel Ely House, built in 1780, is considered one of the best examples of Georgian architecture in western Massachusetts. Nathaniel Ely's fourth wife was the widow Martha Williams Reynolds, daughter of Rev. Stephen Williams. Around 1800, Eleazer and John Williams, two great-grandsons of Eunice Williams's (Stephen's sister, the unredeemed captive), came from Canada to be educated in Longmeadow and lived with the Ely family. (Longmeadow Historical Society, Paesiello Emerson Collection.)

Deacon Nathaniel Ely (1716–1799) married Abigail Colton (1724–1770); their youngest son, William, was a Yale graduate, lawyer, and US representative from Massachusetts who married Abigail Bliss in 1803. Deacon Ely was a captain in the Revolutionary War and kept Tory prisoners in transit between Boston and New York during the war. (Longmeadow Historical Society.)

Eunice Williams, daughter of Rev. John Williams, was eight when captured in the Deerfield Massacre. She was adopted by a Catholic Mohawk family that had lost a daughter to smallpox and was given the Indian name A'ongote ("she has been planted as a person"). At 16, she married a Mohawk man, Francois-Xavier Aronsen, and had a family. Despite repeated attempts to redeem her from captivity, she chose to remain with her new family. Much later in life, now known as Gannenstenhawi ("she brings in corn"), she made several visits to her brother, Rev. Stephen Williams, in Longmeadow, reportedly preferring to camp out "Indian-style" in the orchard behind the parsonage. Two of her great-grandsons were educated in Longmeadow. Though no photographs exist of Eunice, her story has been depicted by a number of artists. This illustration from the February 1880 *Harper's Magazine* was created by Charles Stanley Reinhart. (Library of Congress.)

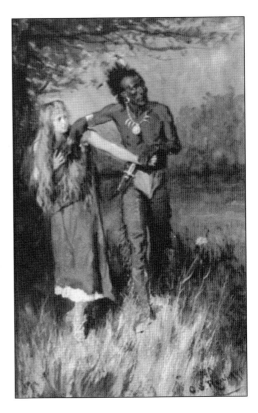

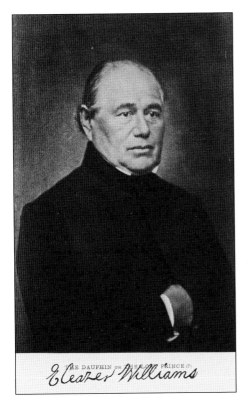

THE DAUPHIN OR THE LOST PRINCE (?)
Eleazer Williams

Eleazer Williams was a great-grandson of Eunice Williams. He was sent from Canada to Longmeadow around 1800 for schooling, sponsored by relatives in the Ely family. By 1839, he was living in Western New York, and a story began to circulate that he was the lost dauphin and heir to the French throne. An 1831 encounter with the Prince de Joinville, younger son of King Louis Philippe I of France, on a Great Lakes steamboat added fuel to the fire. While controversy ruled for the next decade, this delusion of grandeur was proved a hoax. (Longmeadow Historical Society.)

The Keep-Allen House at 1401 Longmeadow Street was built in 1782. A grandson of John Keep (see introduction), Samuel Keep (1739–1823) served in the Revolutionary War, built this house, and farmed land along Longmeadow Street at the corner of Maple Road. Nathan Cooley Keep, a pioneer in dentistry and the first dean of the Harvard Dental School, was likely born here. Briton P. Allen later owned the property; the Allen family managed a dairy farm here from 1890 to 1910. (Longmeadow Historical Society.)

This house at 878 Longmeadow Street was built in 1795 for Dr. Benjamin Stebbins and his spouse, Lucy Colton, daughter of Samuel "Marchant" Colton. Originally all brick and painted red, the house was expanded and remodeled by a later owner, who preserved the front rooms on the first story. In 1910, when this photograph was taken, it was home to Henry Bowles, owner of the Baltimore Lunch chain in Springfield, US congressman, and supporter of the Bowles Agawam Airport in Agawam. (Longmeadow Historical Society, Paesiello Emerson Collection.)

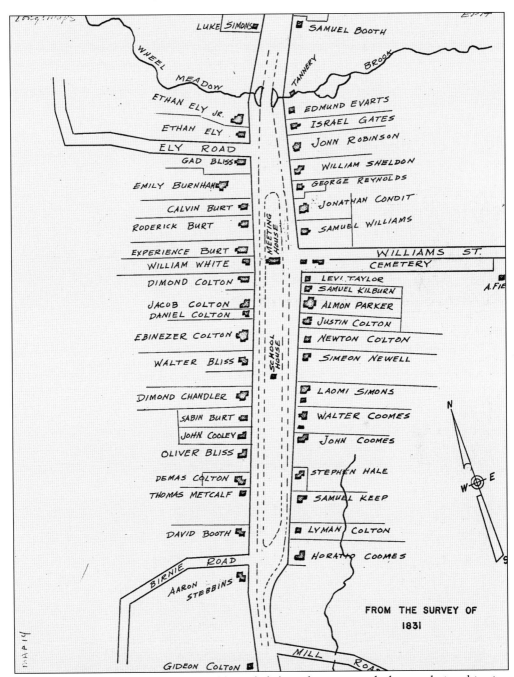

By 1831, Longmeadow had become thickly settled along the green, with the population thinning out north to the bridge over Pecousic Brook and south to the border with Enfield, Connecticut. Since 1703, familiar names such as Colton, Bliss, Burt, and Keep had been joined by Burnham, Chandler, Coomes, Gates, Newell, Reynolds, Stebbins, Sheldon, and White. (Longmeadow Historical Society.)

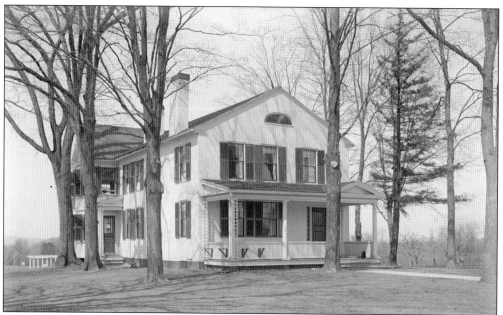

Judah Cooley was a successful farmer who built this home in 1831. He sold the house to Cyrus Newell, who ran a dairy farm and apple orchard. The house, pictured in 1915, is still standing, but the farm and orchard became part of the Englewood Road development in the 1930s. (Longmeadow Historical Society, Paesiello Emerson Collection.)

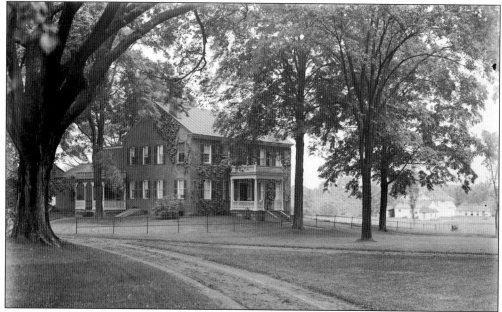

Clay from the meadows was fired to create the bricks used to build this Federal-style house in 1827. The original owner was Calvin Cooley, a descendant of Benjamin Cooley, who had built the first Longmeadow house in 1644. Calvin's son James Cooley was a Yale Law School graduate who became America's first chargé d'affaires (ambassador) to Peru in 1827 but died only a short time later. His niece Caroline Cooley Eveleth later occupied the dwelling. (Longmeadow Historical Society, Paesiello Emerson Collection.)

William Sheldon, a great-grandson of Rev. Stephen Williams, is one of the more colorful characters in Longmeadow history. An opium eater, he lived as a recluse at the northeast corner of the green and seldom ventured outside, though he cordially received visitors. A student of occult lore, he was devoted to the study of spiritualism, magnetism, and the "Od Force." He reportedly believed that England was the Chosen Land and often dressed in pre-Revolutionary British garb. He published several books, including one suggesting fanciful inventions such as machines for flight. He died in 1872 at the age of 84. (Longmeadow Historical Society.)

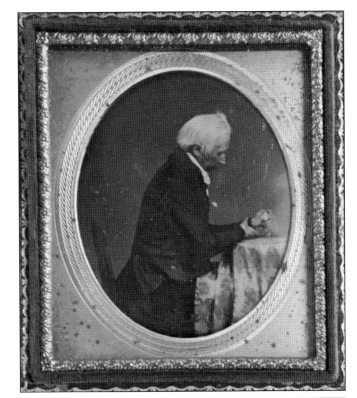

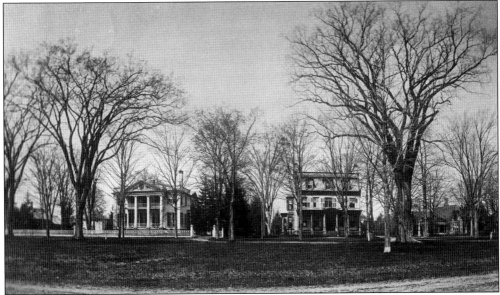

The west side of the green is pictured around 1883. On the left is the Wolcott (formerly Roderick Burt) house, which was destroyed by fire in April 1884; the Brewer-Young Mansion occupies the site today. The Medlicott family then occupied the former Calvin Burt home (center); a newer brick structure replaced this house in 1925. Barely visible to the right is the Roderick Burnham house, built in 1845 of Longmeadow brownstone. This beautiful Gothic structure still stands. (Longmeadow Historical Society.)

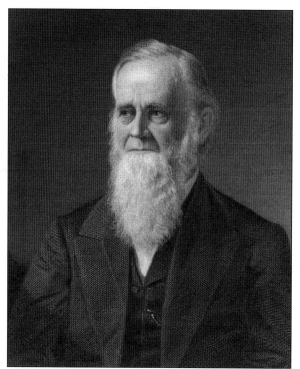

Rev. Samuel Wolcott, DD (1813–1884), was the fifth pastor of the First Church, serving from 1843 to 1847. A poet and musician, he composed more than 200 hymns, including the well-known "Christ for the World We Sing." His son, Edward Oliver Wolcott (1848–1905), was a Civil War veteran and became a US senator representing Colorado. (Longmeadow Historical Society.)

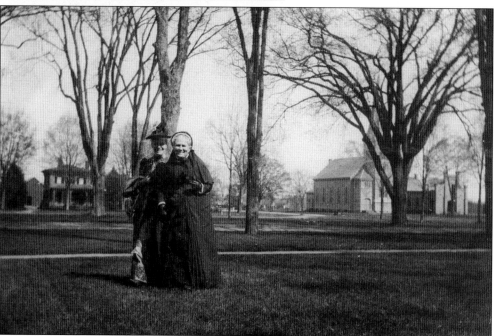

The Wolcotts left Longmeadow in 1847 and served pastorates in Belchertown, Massachusetts, Providence, Chicago, and finally in Cleveland. They retired back to Longmeadow, but the reverend died shortly thereafter. Harriet A. Pope Wolcott, Reverend Wolcott's widow, and Clara Wolcott are pictured on the green about 1888. In back, on the left, is the church parsonage. The church and the chapel are visible on the right across the green. (Longmeadow Historical Society.)

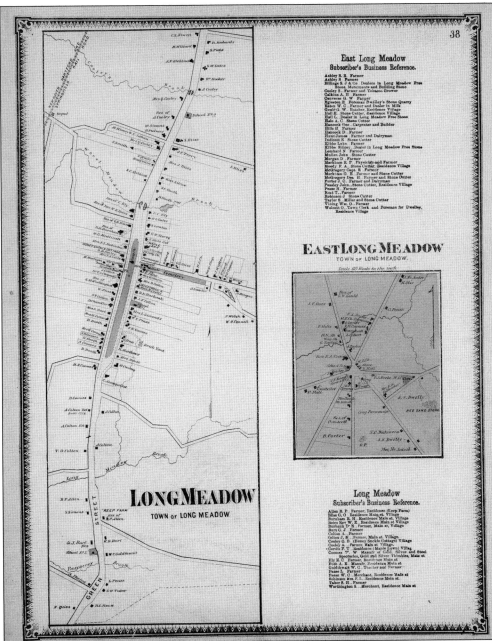

East Long Meadow
Subscriber's Business Reference.

Ashley S. R. ..Farmer
Ashley S ..Farmer
Billings S. J. & Co ..Dealers in Long Meadow Free Stone, Monuments and Building Stone
Cooley S. ..Farmer and Tobacco Grower
Calkins A. H ..Farmer
Converse G. W ..Farger
Egleston E ..Foreman Dwelley's Stone Quarry
Eaton W. C. ..Farmer and Dealer in Milk
Gould G. W. ..Butcher, Residence Village
Hall E. ..Stone Cutter, Residence Village
Hall L. ..Dealer in Long Meadow Free Stone
Hale A. C. ..Stone Cutter
Hancock Geo. ..Carpenter and Builder
Hills H ..Farmer
Hancock D. ..Farmer
Hanz James ..Farmer and Dairyman
Indicott E ..Stone Cutter
Kibbe Luke. ..Farmer
Kibbe Sidney. ..Dealer in Long Meadow Free Stone
Lombard N ..Farmer
William John ..Stone Cutter
Morgan D ..Farmer
Markham R. F ..Physician and Farmer
Moody F. A. ..Stone Cutter, Residence Village
McGregory Capt. E ..Farmer
Markham G. E. ..Farmer and Stone Cutter
McGregory Dea. H. ..Farmer and Stone Cutter
Porter J. O. ..Farmer and Dairyman
Peasley John. ..Stone Cutter, Residence Village
Pease H. ..Farmer
Rust T. ..Farmer
Robinson J ..Stone Cutter
Taylor S. ..Miller and Stone Cutter
Vining Wm. O. ..Farmer
Wolcott O. ..Town Clerk and Foreman for Dwelley, Residence Village

EAST LONG MEADOW
TOWN OF LONG MEADOW.
Scale 60 Rods to the inch

Long Meadow
Subscriber's Business Reference.

Allen H. P. ..Farmer, Residence (Keep Farm)
Bliss G. O ..Residence Main st., Village
Burnham R. H. ..Residence Main st, Village
Boies Rev W. E. ..Residence Main st at Village
Burbank D. K. ..Farmer, Main st, Village
Burt G. J ..Farmer
Colton A ..Farmer
Colton J. N. ..Farmer, Main st. Village
Cooley O. B. ..(Honey Suckle Cottage) Village
Cooley A. ..Farmer, Main st. Village
Cordis F. T. ..Residence (Maple Lawn) Village
Coomes W. W ..Manufr of Gold, Silver and Steel Spectacles, Gold and Silver Thimbles, Main st
Ely E. C ..Farmer, Residence Main st
Foth A. E ..Manufr, Residence Main st
Goldthwait W. G. ..Teacher and Farmer
Pease I. ..Farmer
Pease W. G. ..Merchant, Residence Main st
Robinson Mrs. F. L. ..Residence Main st.
Tabor S. H. ..Farmer
Worthington S. ..Merchant, Residence Main st

LONGMEADOW
TOWN OF LONG MEADOW

Longmeadow's growth is evident in this 1870 map. At this time, the main road was called "Green Street"; at various times, it has been called the Country Road, Main Street (around 1894), and Longmeadow Street (from around 1912 to today). As part of the Boston Post Road, it was designated Route 2 before US routes were re-designated with odd numbers for north–south highways and even numbers for east–west highways. Today, it is US Route 5. The inset on the map shows the growing east village with a greater number of business subscribers. The sandy land along Williams Street connecting the east and west villages was unsuited for farming and sparsely inhabited. (Longmeadow Historical Society.)

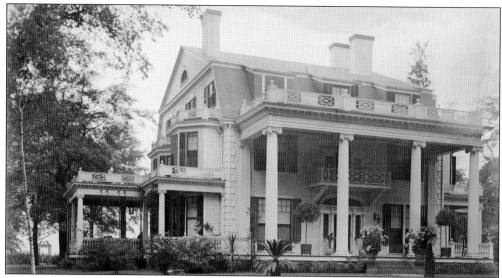

The home of Roderick and Charlotte Burt occupied 734 Longmeadow Street. In 1883, two sons of former minister Samuel Wolcott purchased the estate as a retirement home for their parents. Sadly, the original home was destroyed by fire during renovations, and Reverend Wolcott died before completion of the present-day Brewer-Young Mansion in 1884. His widow Harriett (see page 28) lived there until 1901. The next owners were Edward and Corinne Brewer. (Longmeadow Historical Society, Paesiello Emerson Collection.)

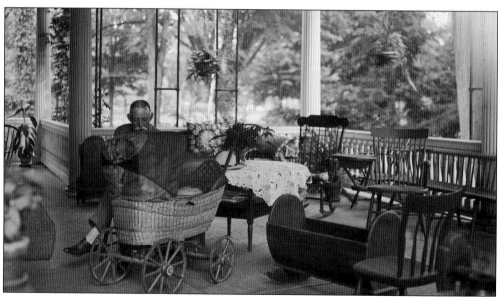

Edward Spaulding Brewer had been the proprietor of the Ocean House, a large Victorian waterfront hotel in Westerly, Rhode Island. Likely with that building in mind, he replaced the original brown shingles on his new Longmeadow home with white clapboards. Presumably watching a grandchild in the baby carriage, Edward is pictured here in 1908 on the south porch of his mansion. After his widow, Corinne Brewer, died in 1921, the home was sold to Mary Ida Young, who occupied the residence until her death at age 95 in 1960. (Longmeadow Historical Society, Paesiello Emerson Collection.)

Properties on the west side of Longmeadow Street originally stretched west to the Connecticut River. The size of the farms, and later estates, began to shrink first with the coming of the railroad, then with subdivision for housing, and finally with construction of Interstate 91. In 1908, E.S. Brewer's road negotiated the change in elevation from the house to the low-lying meadow. (Longmeadow Historical Society, Paesiello Emerson Collection.)

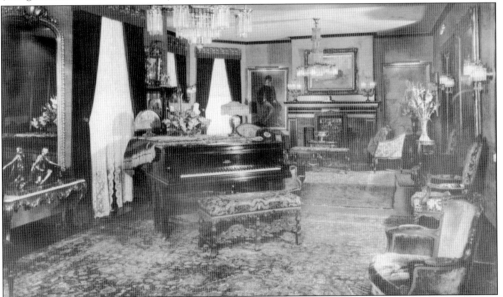

Wilbur Fenelon Young, who delivered cargo with horses, and his herbalist wife, Mary Ida Young, invented a horse liniment called Absorbine. The W.F. Young Company was founded in 1892 to produce Absorbine and later Absorbine Jr. for human use after horsemen and farmers claimed to be using the liniment on themselves. Successful in business, the widow Mary Ida entertained lavishly. This photograph shows the main parlor of her 10,900-square-foot home in 1923. The house has a glassed-in conservatory fashioned after the Crystal Palace in England. (Longmeadow Historical Society.)

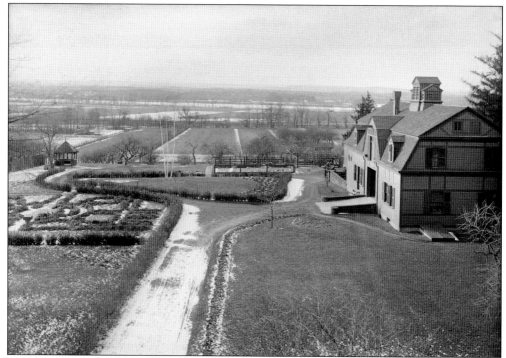

Mary Ida Young called her 18-acre estate Meadowbrook Farms and made it a showcase for black Persian sheep, cows, chickens, and deer. This 1908 photograph, taken when the property was still in the Brewer family, shows the barn, formal garden, roads, and fields stretching all the way to the Connecticut River. Agawam and the foothills of the Berkshires are visible in the distance. The extensive estate was truncated by the construction of Interstate 91 in the late 1950s. (Longmeadow Historical Society, Paesiello Emerson Collection.)

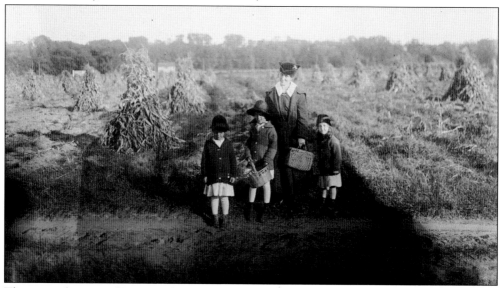

The pastoral nature of Longmeadow is still evident in this 1918 photograph. Here, the Campbell family poses for a picture amid the haystacks near the riverbank. (Longmeadow Historical Society, Paesiello Emerson Collection.)

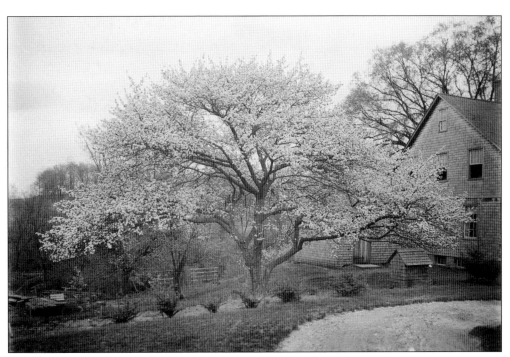

S.C. Fay was an architect whose Bonniewood estate was just north of Mill Street at the lower end of the green. In this 1912 photograph, one of his apple trees is in full bloom. While apples were prized for eating, the major use was for production of hard cider. In the days before bacterial contamination of water was understood, cider and beer were safer beverages. (Longmeadow Historical Society, Paesiello Emerson Collection.)

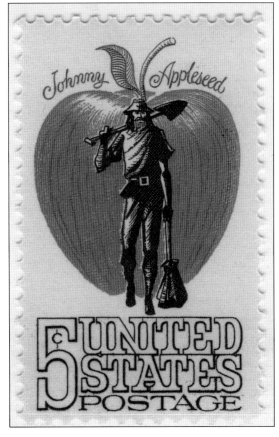

American folk hero John Chapman (Johnny Appleseed) was born in Leominster, Massachusetts, in 1774 but grew up in Longmeadow. The Chapman home still stands on Fairfield Terrace, although it has been twice moved from its original location. By the early 1800s, Johnny took advantage of frontier law allowing people to homestead land; planting 50 apple trees could satisfy a claim. Chapman started orchards in Pennsylvania, Ohio, and Illinois and later sold them to settlers. At the time of his death in 1845, he owned over 1,200 acres. This commemorative stamp and first-day cover date from 1966. (Author's collection.)

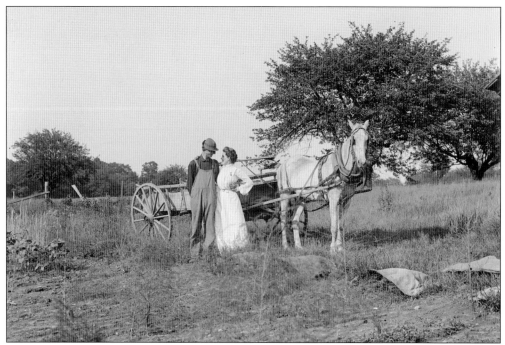

This early-20th-century photograph taken by Paesiello Emerson is thought to be of his younger half brother Henry and a woman identified as Edna, possibly their niece. The Emerson family owned the land at the northwest corner of Longmeadow Street and Depot Road, later renamed Emerson Road in their honor. The property is now part of Bay Path University. (Longmeadow Historical Society, Paesiello Emerson Collection.)

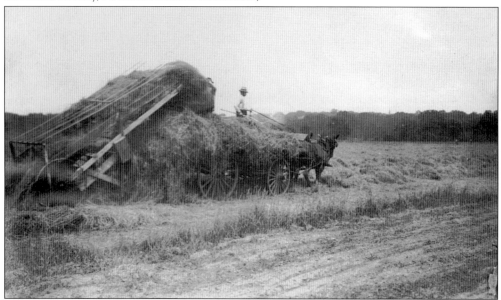

Local transportation involved horses until the advent of the automobile and the electric streetcar. Each horse required 10 to 20 pounds of hay daily, as most urban animals lacked free access to graze. In this undated photograph, a worker is harvesting hay from fields in the meadows. (Longmeadow Historical Society.)

Three

TRANSPORTATION IN LONGMEADOW

Prior to automobiles and streetcars, roads needed only be wide enough for two wagons to pass. Although Longmeadow Street was laid out with generous proportions along the green, it narrowed considerably going north over Wheelmeadow Brook, pictured here sometime before 1895. The David Booth house at 609 Longmeadow Street, built in 1861, is in the background. (Longmeadow Historical Society.)

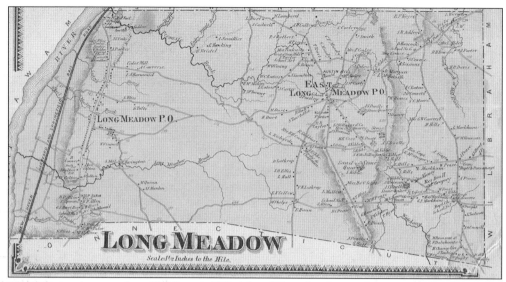

The Longmeadow page from F.W. Beers's 1870 *Atlas of Hampden County* shows uninhabited stretches along Converse, Bliss, and Williams Streets heading east to the village of East Longmeadow, which was part of the town but with a separate post office. The town's boundaries extended east to Wilbraham and well north of Pecousic Brook, which was later dammed to form Porter Lake. The brow of the hill overlooking the meadows is evident, as is the New Haven, Hartford & Springfield double-tracked railroad line through the meadows. (Author's collection.)

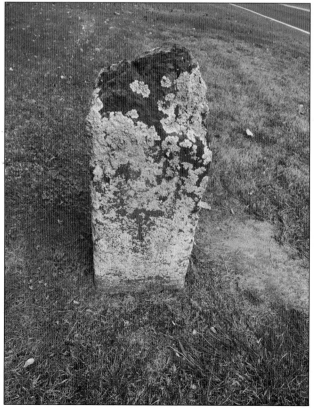

One of Longmeadow's last remaining milestones sits several yards away from Route 5 across from the Storrs Library. Nearly illegible today, it once indicated a distance to Hartford (Connecticut) of 22 miles. The other remaining milestone is pictured on page 14. (Author's collection.)

Travel was difficult in the 17th and 18th centuries. Native American trails were widened to accommodate horses and coaches; two routes between Boston and New York were designated as branches of the Boston Post Road. The northern route went from Boston to Springfield (more or less parallel to modern US 20), then along the Connecticut River through Hartford to New Haven (parallel to modern US 5), where it joined the southern route (today's US 1 route). Longmeadow Street is pictured in this view looking north at the Boston Post Road marker indicating 22 miles to Hartford. This view looks in the same direction as the one on page 35 but some 100 yards to the south. The dip in the land identifies where Wheelmeadow Brook runs under the road in a culvert. (Longmeadow Historical Society.)

This 1916 photograph shows T.W. Leete's fields and barn on the road to East Longmeadow (present-day Bliss Road and Williams Street east of the Longmeadow Shops). Travel from the east to the west village was several miles on foot or by carriage; even after the advent of streetcars, there was no direct rail connection between the two towns. Much of the distance was uninhabited sand and scrub forest; the land was not well suited for agriculture. (Longmeadow Historical Society, Paesiello Emerson Collection.)

The east village of Longmeadow initially settled slowly; it was derisively known as "Poverty Hill" because of the poor land. When quarries opened in the 1850s, the population grew and then exceeded that of the west part of town. The Longmeadow Town Hall was built in 1882 with Longmeadow brownstone donated by the nearby Norcross Company. Located at what is now the East Longmeadow rotary, it served both villages until East Longmeadow separated on July 1, 1894. At the time of the division, more than two-thirds of the population lived in what became East Longmeadow. (Longmeadow Historical Society.)

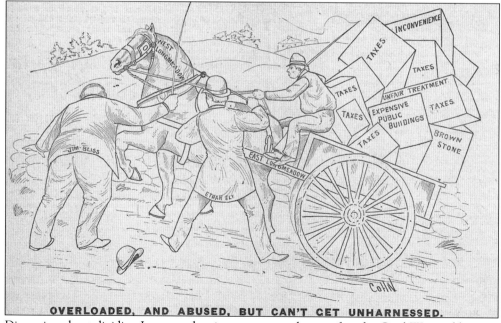

OVERLOADED, AND ABUSED, BUT CAN'T GET UNHARNESSED.

Discussion about dividing Longmeadow into two towns began after the Civil War and became heated by the 1880s. More affluent west-side residents resented the increasing tax burden needed to support schools and booming east village growth, driven in part by the quarry industry and an influx of immigrant workers and their families. This cartoon from April 1892 captures the sentiment of many west-siders. (Longmeadow Historical Society.)

This 1911 photograph captures the green in a view looking south. Following the town's division, Longmeadow's wealthier population lived in large homes on Longmeadow Street, with some working farms persisting. The town increasingly attracted professionals and businessmen, some of whom commuted to Springfield. East Longmeadow had more small farms, small businesses, and 17 stone quarries, of which 12 were active in 1894. Each town had its own railroad station, post office, churches, grocery stores, schools, and blacksmiths. (Longmeadow Historical Society, Paesiello Emerson Collection.)

Francis Temple Cordis and Ruth Anne Cordis lived at 715 Longmeadow Street when transportation was still horse-powered. Their carriage is a one-horse chaise, sometimes referred to as a gig or a shay. The light, two-wheeled carriage carried one or two people and had a folding hood. The Cordis home, built in 1832, has Federal-style brick construction but is oriented with the gable end facing the street in a nod to the then popular Greek Revival style. Prior to the Cordis family purchase in 1845, it was the home of Rev. Jonathan Condit and Rev. Hubbard Beebe. (Longmeadow Historical Society.)

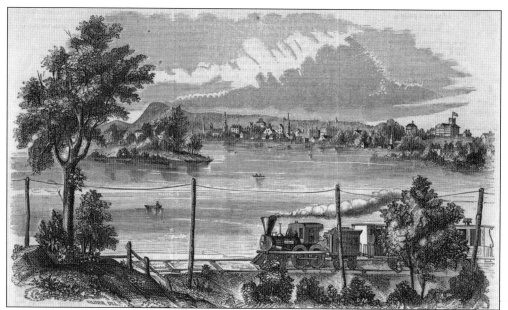

As early as 1793, proposals were floated to connect the Connecticut and Charles Rivers to facilitate inland transport of goods. While the 1803 Middlesex Canal in eastern Massachusetts became a model for subsequent canals, including New York's Erie Canal, the development of railroads shortly thereafter provided a better solution. The Western Railroad (predecessor to the Boston & Albany) joined Boston to Springfield in 1839. In 1844, the Connecticut River Railroad opened a north–south line connecting Springfield with New Haven and New York. This woodcut, published in *Gleason's Pictorial Drawing-Room Companion* in the early 1850s, shows a train on the Longmeadow tracks with Springfield upriver. (Author's collection.)

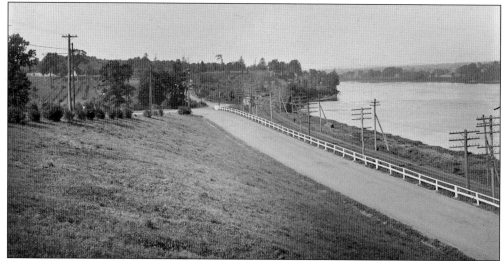

This 1907 image from Forest Park shows Longmeadow in the distance downriver. Aside from the river and the train tracks, the location would be difficult to recognize today; the spaghetti junction of US 5, Interstate 91, and the South End Bridge have forever changed the scenery. To the right of the Longmeadow Road (also called Pecousic Boulevard) are the tracks of the New York, New Haven & Hartford Railroad (NYNH&H), successor to the Connecticut River Railroad. (Longmeadow Historical Society, Paesiello Emerson Collection.)

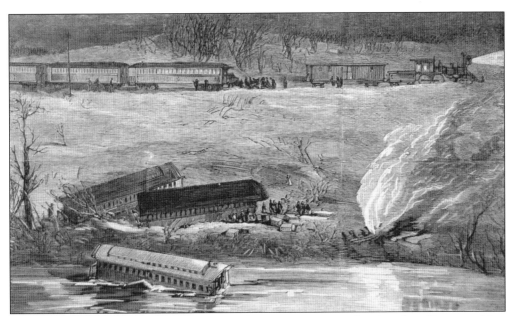

On March 8, 1872, a serious accident occurred on an express train heading from Boston to New York via Springfield. The Connecticut River curves sharply at the Springfield-Longmeadow border, and at this place, a broken rail launched the mail car and baggage car into the river, with two passenger cars rolling down the embankment. Remarkably, no one died at the scene, although 20 were wounded. This sketch appeared in *Harper's Weekly* on March 23, 1872. (Longmeadow Historical Society.)

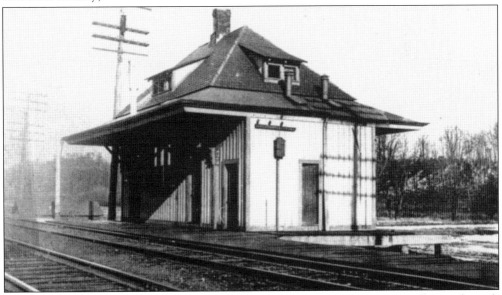

Railroad service to Longmeadow began in 1844, and while Amtrak trains still pass through the meadows, scheduled stops in Longmeadow ended in 1908. The railroad station was initially on the north side of Depot (now Emerson) Road, was moved to the south side sometime after 1894, and was finally moved away from the tracks after regular passenger service ended. It still stands as a maintenance building for the town's public works department. (Longmeadow Historical Society.)

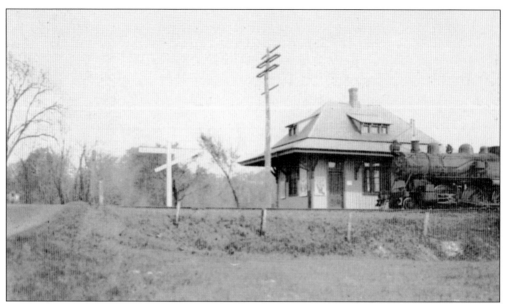

The first Longmeadow station was built in 1845; by 1884, a larger station, pictured here, was built next to the original station, which was carted off to become a private home nearby. This station remained busy until the early 1900s, when competition from trolleys and automobiles caused its demise. (Longmeadow Historical Society.)

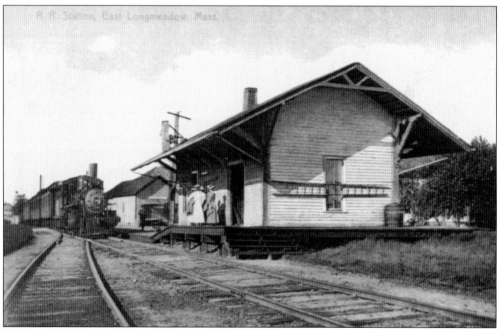

The New London, Willimantic & Springfield Railroad was proposed in 1848; eventually, this line became a branch of the Hartford & New Haven Railroad connecting the east village with Springfield. The east village line, pictured on this 1910 postcard, opened in 1876, carrying not only commuters but also quarried sandstone to New York City and other building sites. (East Longmeadow Historical Society.)

The road to the train depot in Longmeadow, shown in 1909, was originally (and logically) called Depot Road. The depot was one of the busiest on the NYNH&H line, and Longmeadow passengers could arrange for rides to and from the station. Sometime after the depot closed, the road was renamed for the Emerson family, whose property abutted the road. (Longmeadow Historical Society, Paesiello Emerson Collection.)

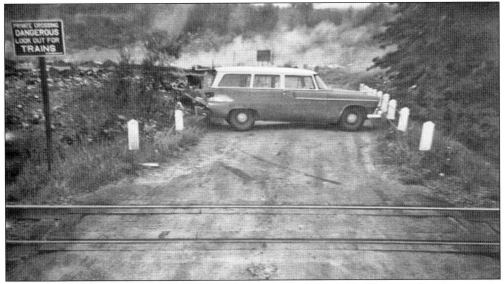

Several roads cross the railroad tracks into the meadows, but only the Emerson Road crossing is protected with gates and flashing lights. The crossing at Birnie Road has been the site of several fatal accidents over the years, most recently when Warren Cowels, a longtime town public works employee, was killed when a northbound Amtrak train struck his snowplow during Winter Storm Stella in 2017. This crossing is pictured in 1960. (Longmeadow Historical Society.)

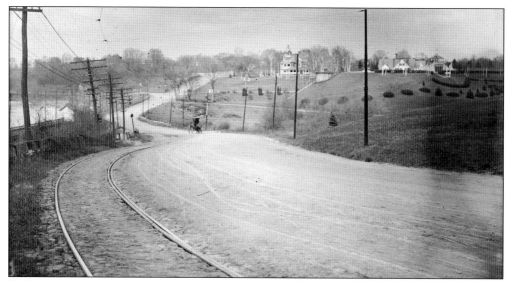

Trolley cars of the Springfield Street Railway connected Springfield with Longmeadow down to the state line in Enfield by 1896. This frequent and relatively inexpensive transport facilitated Longmeadow's development as a streetcar suburb. While much of the line was eventually double-tracked, the climb from Pecousic Brook to Longmeadow Street was a single track in 1909. Pecousic Villa, the home of rolling-skate entrepreneur Everett Hosmer Barney, is visible in the distance, with his carriage house to the right. The small building to the left is the Pecousic train station. (Longmeadow Historical Society, Paesiello Emerson Collection.)

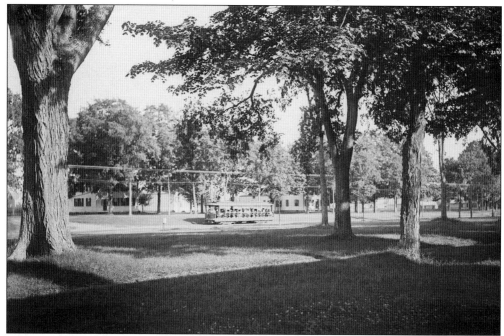

In the early days of electric rail transport, streetcar companies maintained two sets of vehicles: closed cars for inclement weather and open bench cars for nicer days. Shown here around 1911 is an open car on Longmeadow Street near the corner of Bliss Road. (Longmeadow Historical Society, Paesiello Emerson Collection.)

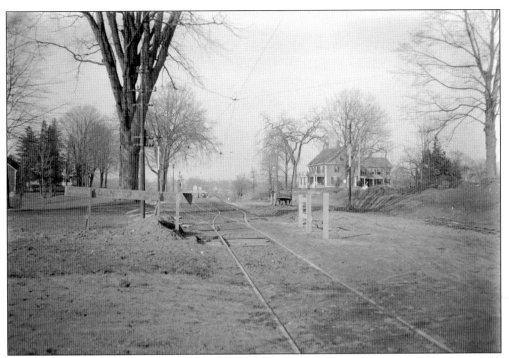

Much of the Longmeadow streetcar line was initially single-track, with occasional passing tracks to allow trolleys to pass in opposite directions. This 1911 image shows where the single-track line became a double-tracked right-of-way on the green, just south of the Wheelmeadow Brook. Trolley riders included not only businessmen and shoppers but also students attending high school in Springfield when the town did not have its own high school. (Longmeadow Historical Society, Paesiello Emerson Collection.)

Both the Springfield Street Railway (SSR) and the interurban Hartford & Springfield Street Railway (HSSR) used the tracks through Longmeadow. Starting in 1902, the latter concern operated high-speed interurban cars on the east side of the Connecticut River, and by 1904, it also ran on the west bank through Windsor Locks, Suffield, and Agawam. On November 18, 1905, a disastrous collision occurred between an SSR car and an HSSR car south of the green; it killed a motorman and injured many passengers. This period postcard shows heavily damaged HSSR car 19. Operation on a single track and poor visibility due to the hilly right-of-way were factors contributing to the accident. (Longmeadow Historical Society.)

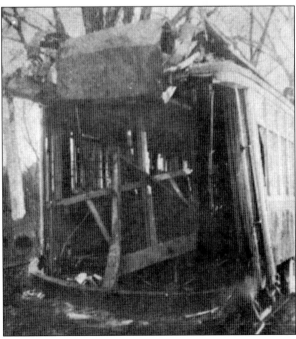

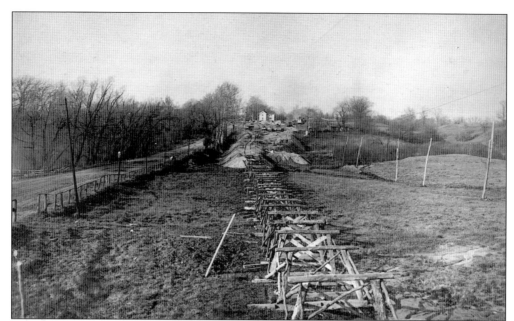

Following the fatal collision, work commenced in 1907–1908 to lay a second set of tracks through most of Longmeadow, along with the regrading, straightening, and widening of Longmeadow Street. Trestles were built to support the trolley tracks; sand from the eastern part of town was used to regrade the road to the new, higher level. Arches were created over the ravines at Wheelmeadow and Longmeadow Brooks to channel the streams under the new road. (Longmeadow Historical Society, Paesiello Emerson Collection.)

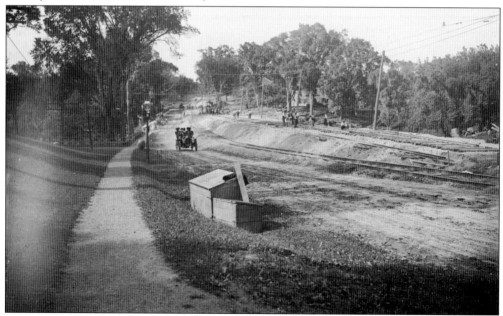

Work is progressing on Longmeadow Street and the trolley tracks in this July 1908 photograph near Wheelmeadow Brook. An automobile chugs along the old road while workers lay railroad ties on the newly elevated section to the east. The David Booth home at 609 Longmeadow Street can be seen on the right. (Longmeadow Historical Society, Paesiello Emerson Collection.)

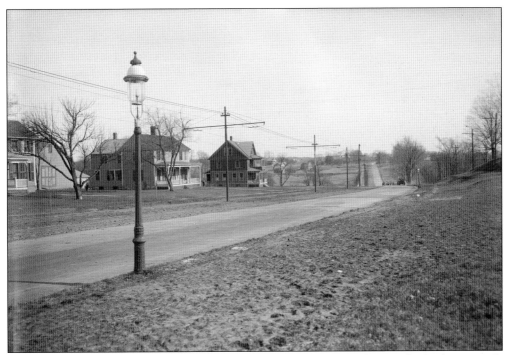

Longmeadow Street south of Maple Road had yet to experience substantial suburban growth when this image was captured in 1915. In this view looking south, the trolley tracks have been double-tracked; gas lamps still provide illumination. (Longmeadow Historical Society, Paesiello Emerson Collection.)

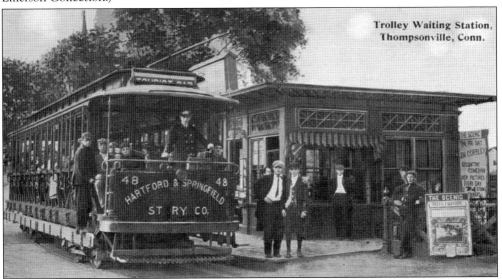

Connecting to the local street railway systems in each city, the Hartford & Springfield Street Railway opened its main line along Route 5 on the east side of the Connecticut River in 1902. A branch extending from Thompsonville to Somers, Connecticut, opened in 1902 and one from Warehouse Point to Rockville, Connecticut, in 1906. The trolley waiting station in Thompsonville, Connecticut, was a transfer point between lines. Interurban trolley service was discontinued in 1926 and replaced with motor coaches. (Author's collection.)

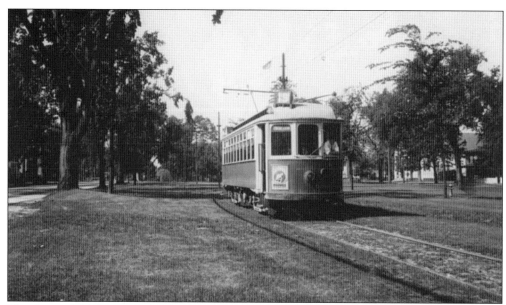

The Springfield Street Railway was one of five streetcar systems owned by the New England Investment & Security Company, a subsidiary of the New Haven Railroad. Equipment was often purchased jointly with the Worcester Consolidated Railway and the Berkshire Street Railway. One of SSR's suburban cars of the 400 series is shown on Route 19 through Longmeadow in 1937. (Jack Hess.)

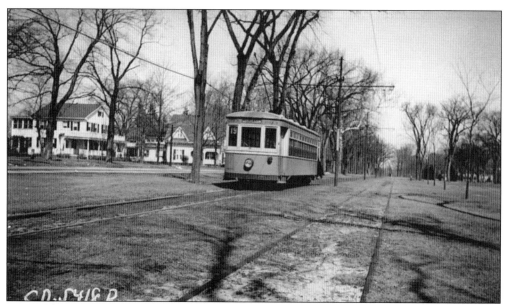

Most of the SSR fleet was built at the Wason factory in Springfield. Car 561, photographed in 1937, was one of a 50-car order delivered to the Springfield Street Railway in 1927. When trolley service ended, most of these cars were sold to Montreal Tramways Company (MTC), while the remainder went to the Virginia Electric and Power Company in Norfolk. Sister car 575 became MTC 2056 and is now preserved at the Connecticut Trolley Museum in nearby Windsor. (Jack Hess.)

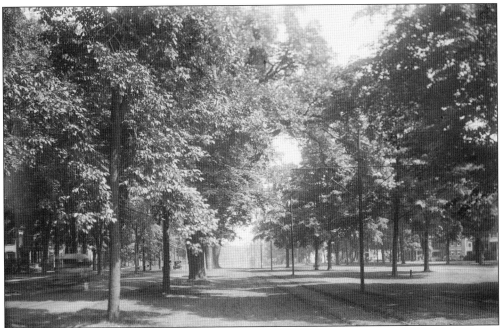

Dutch elm disease was first reported in the United States in 1928 and spread from New England westward and southward by the 1940s. Elm trees are still prominent on Longmeadow Street in this 1911 photograph. New Haven, about 60 miles south of Longmeadow, was once known as "Elm City" prior to the near complete destruction of its famous elms. (Longmeadow Historical Society, Paesiello Emerson Collection.)

Springfield was a center of automobile manufacturing, beginning with the Duryea brothers and their first gasoline-powered automobile in 1893. Some Longmeadow residents were early adopters, even before the advent of the Ford Model T made cars increasingly affordable for the masses. Edwin D. and Augusta M. Hibbard pose with their auto in their backyard at the corner of Longmeadow Street and Hopkins Place in 1913. (Longmeadow Historical Society, Paesiello Emerson Collection.)

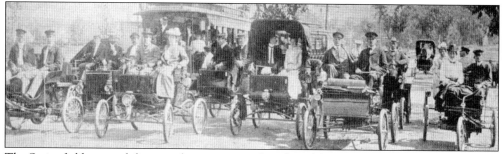

The Springfield automobilists are shown starting their first club run to Russell, Massachusetts, on August 11, 1901. On the right is Dr. Harry Martin of Longmeadow piloting a Knox three-wheeler. Major Martin later served as a regimental surgeon on the front lines in France during World War I. Automobiles were curiosities during the first decade of the 20th century before introduction of the Ford Model T in 1908. (Jack Hess.)

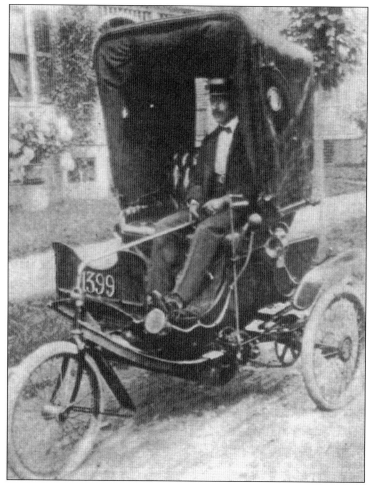

The Knox Automobile Company of Springfield was established in 1900. Initially building three- and four-wheel runabouts, it later expanded to become a major manufacturer of trucks, tractors, and fire engines. Shown here is Dr. Harry C. Martin of Longmeadow piloting his 1901 single-cylinder Knox three-wheeler, which weighed 850 pounds, reached 18 miles per hour, and got about 18 miles per gallon. (Jack Hess.)

Aviation in the Springfield area began at Longmeadow's Dunn Field in 1927, predating the Springfield Airport, Bowles Agawam Airport, Barnes Field, Westfield, Riverdale Airport, Westover Field, and Bradley Field. Dunn Field, located on the banks of the Connecticut River, was named after the farmer who owned the property. An aerial pageant was held on September 3, 4, and 5, 1927, with Army, Navy, National Guard, and civilian planes competing in races. Parachute jumps and passenger rides were part of the festivities. A photographer for the *Springfield Republican* captured the Labor Day event. Periodic flooding ultimately forced relocation of the airport. (Longmeadow Historical Society.)

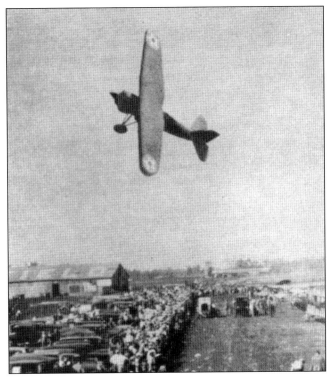

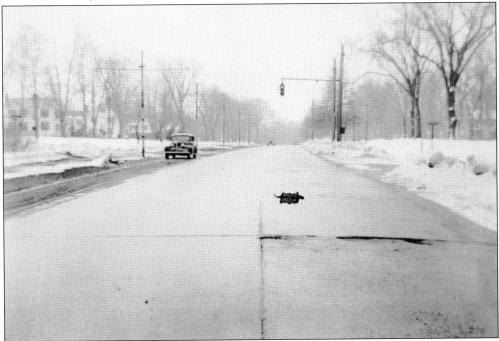

Longmeadow Street is pictured in March 1940; the stoplight is at the junction with Converse Street. The automobile, possibly a police car, is stopped facing north on the southbound trolley track. Service on this line would end two months later. The tracks were later removed to supply steel for the war effort. (Longmeadow Police Department.)

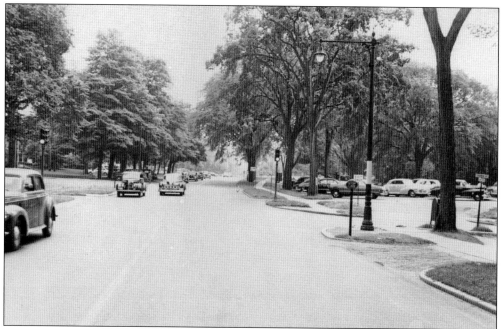

In May 1951, in this view looking north on Longmeadow Street near the Edgewood block, the cars are newer and the streetcar tracks are gone. The road, which is also US Route 5, was a major thoroughfare before the interstates were built. (Longmeadow Police Department.)

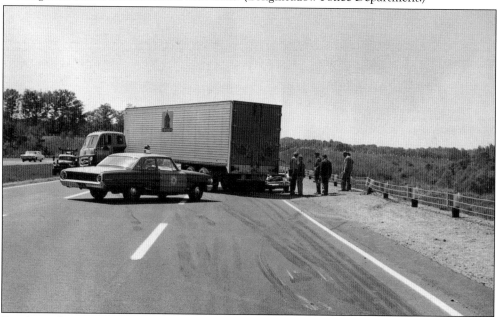

Fast-forward another 13 years to May 1964: Massachusetts State Police are investigating a jackknifed tractor-trailer that has completely blocked the highway just north of the Enfield exit. Interstate 91 is the limited-access road that parallels US Route 5; construction in Massachusetts began in Longmeadow in 1958 and was completed through to Vermont by 1970. The highway extends 290 miles from the junction with Interstate 95 in New Haven, Connecticut, to Derby Line, Vermont, and the road continues into Canada as Autoroute 55. (Longmeadow Police Department.)

Four

THE STREETCAR SUBURB

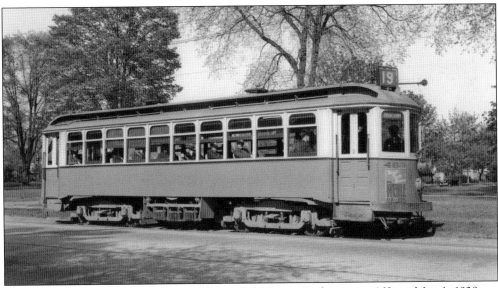

Photographer Roger Borrup captured Springfield Street Railways no. 463 on May 1, 1938, on Longmeadow Street at Ellington Road. Trolleys made commuting to downtown Springfield convenient and inexpensive, fueling the growth of Longmeadow as a streetcar suburb. With the possibility of an easy commute, urban professionals could now work in the city while enjoying the space and gracious living of the country. Brookline and Newton (outside of Boston) and Shaker Heights (outside of Cleveland) are similar streetcar suburbs. (Jack Hess.)

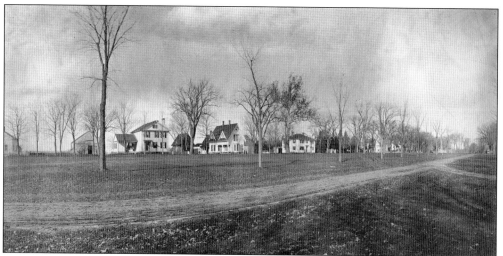

In a view looking northwest across the green, the Chandler, Colton, and G. Bliss houses are pictured from left to right. This undated photograph was taken before the installation of streetcar tracks in 1896, when the town was still a sleepy rural community. Longmeadow in 1894 had just over 100 homes; six years later, the number had nearly doubled to 194 dwellings. (Longmeadow Historical Society.)

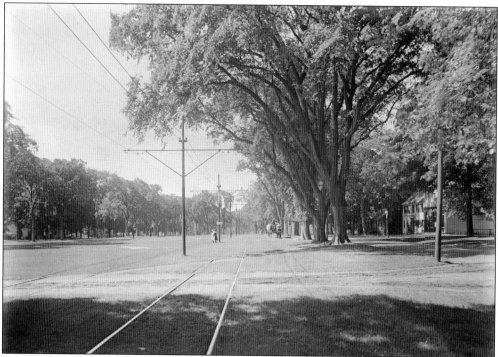

Contrast this picture taken on June 7, 1912, to the previous photograph. The photographer is aiming south along the trolley tracks on the west side of the green; the first building on the left is the C.L. Wood general store on the corner of Longmeadow Street and Chandler Avenue, almost directly across from the First Church. Population growth was facilitated by an 1896 extension of the Springfield Street Railway along Longmeadow Street. (Longmeadow Historical Society, Paesiello Emerson Collection.)

Theodore Woolsey Leete (pictured) and his partners J. William Cheney and Edward Murphy began the development of South Park Terrace in 1898. The 45-acre neighborhood along the northern portion of Longmeadow was the first of many suburban developments to take advantage of the then new streetcar service between Springfield and Longmeadow. (Jack Hess.)

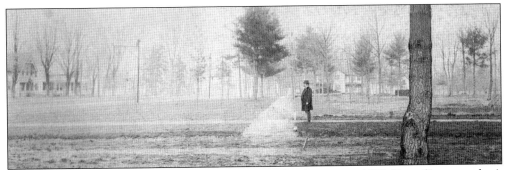

Theodore Leete is looking at his emerging South Park development in 1898. One of Longmeadow's first planned developments, South Park encompassed 45 acres between Converse Street and the Springfield line. The South Park Terrace Company planned 184 building lots priced from $350 to $1,000 each. (Jack Hess.)

Longmeadow Street (US Route 5) and the town green cross from left to right, while the 1921 Community House and the First Church flank Williams Street. In the foreground are the Brewer-Young Mansion with formal gardens and a carriage house. By the time of this photograph, many of the original landholdings that once stretched from Longmeadow Street to the Connecticut River had been subdivided to satisfy a growing demand for housing. This photograph was likely taken on an October 9, 1936, promotional flight of the *Hindenburg* on a round-trip from Lakehurst Field in New Jersey to Boston. The 10½-hour "Millionaire's Flight" included dignitaries such as Nelson Rockefeller. The *Hindenburg* caught fire and exploded on May 6, 1937, at Lakehurst Maxwell Field in New Jersey. (Longmeadow Historical Society.)

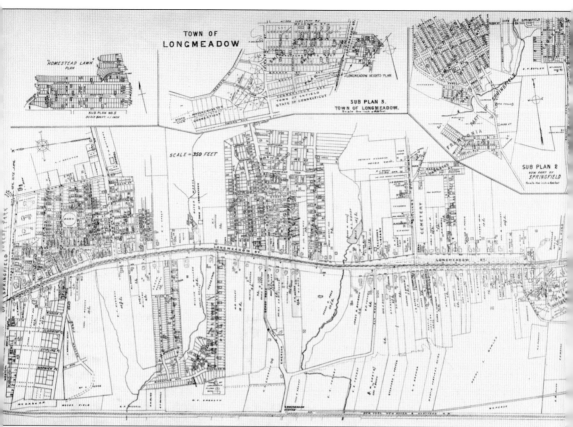

The pace of Longmeadow's suburban development is apparent from this 1912 plan. The South Park development (middle left) still had open lots. Homes were being built on the newly platted Elmwood Avenue and Warren Terrace. Edgewood had been platted. The sub-plans show, from left to right, Homestead Lawn (Barrington Road, Homestead Boulevard, and Meadow Road at the south end of Longmeadow Street); Longmeadow Heights (between the Homestead Lawn development and the Enfield, Connecticut, border) and the Franconia development between Forest Street (now Tiffany Street) and Dwight Road in Springfield. The Franconia neighborhood would be transferred to Springfield in 1914. (Longmeadow Historical Society.)

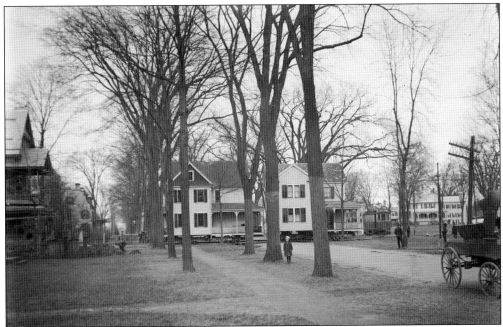

By the time this photograph was taken in 1910, suburban development and town needs were prompting the relocation of homes. The scene is on Longmeadow Street; the trolley in the picture is a work car converted from a passenger vehicle, likely on hand to deal with disconnecting and reconnecting overhead trolley wires for the move. (Longmeadow Historical Society, Paesiello Emerson Collection.)

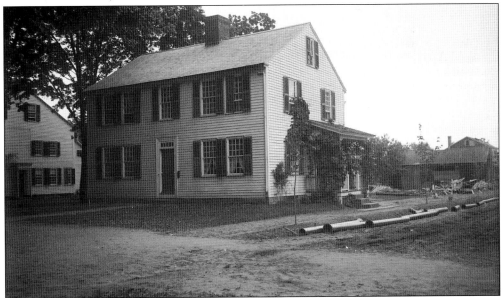

The Newton Colton House was built at 870 Longmeadow Street in 1823 and features a traditional "five over four and a door" facade. It is pictured in 1915 on its original site, now occupied by the Center School. The house was moved across the green in 1923. Reportedly, some of the home's doors and hardware were salvaged from the Parsons Tavern in downtown Springfield. (Longmeadow Historical Society, Paesiello Emerson Collection.)

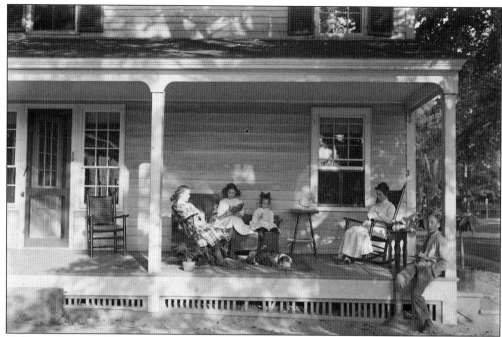

In the era before air-conditioning, porches provided shade in the summer and shelter from the elements in inclement weather. *Veranda, piazza, loggia,* and *portico* were all words used to describe porches in 19th-century America. The Taylor family is pictured on their back piazza in this 1910 photograph. (Longmeadow Historical Society, Paesiello Emerson Collection.)

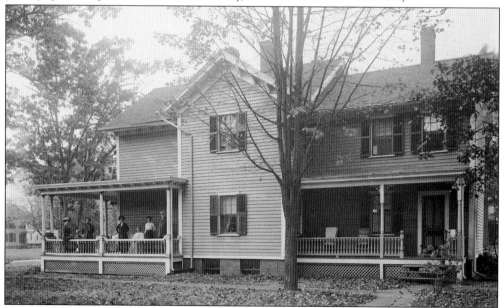

The word *porch* derives from the Latin *porticus,* describing the columned entry to a classical temple, but the American version may have developed from African sources, since porches were uncommon in northern Europe. The Parker household at 43 Longmeadow Street, built in 1905 and pictured in 1910, featured front and side porches. (Longmeadow Historical Society, Paesiello Emerson Collection.)

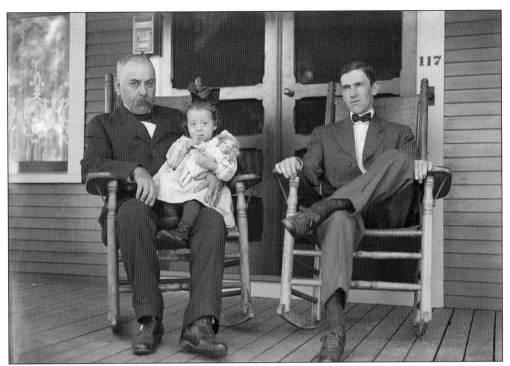

What is better than a porch rocker on a hot summer day? This 1908 photograph shows the G.W. Smith family and appears to depict three generations of the family then living at 117 Longmeadow Street. (Longmeadow Historical Society, Paesiello Emerson Collection.)

Screened porches were popular for bedrooms on hot summer nights. This 1915 image shows "Mrs. Craig's" garage and home on South Park Avenue. (Longmeadow Historical Society, Paesiello Emerson Collection.)

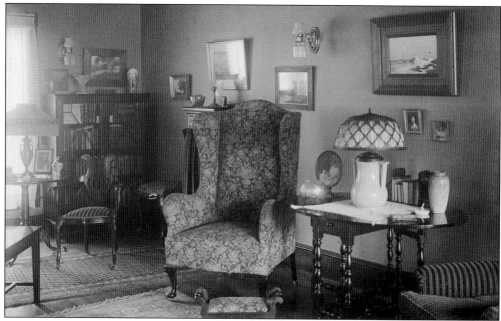

Westmoreland Avenue was laid out east of Longmeadow Street, just south of what is today's Laurel Park. The P.A. Williams family lived at 8 Westmoreland Avenue. Paesiello Emerson captured their parlor in 1919. (Longmeadow Historical Society, Paesiello Emerson Collection.)

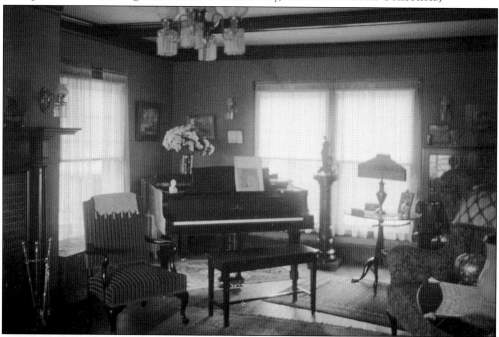

Another 1919 image shows the P.A. Williams parlor, featuring a fireplace, wing chairs, and a baby grand piano built by Steinway & Sons. The crocheted cloth on the armchair is an antimacassar, designed to prevent staining of the fabric. Antimacassars were common in the Victorian and Edwardian eras, when men groomed their hair with Macassar oil. (Longmeadow Historical Society, Paesiello Emerson Collection.)

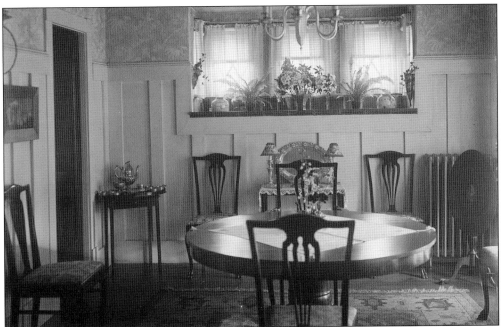

Early-20th-century homes drew on architectural elements of earlier periods. Wainscoting (wooden paneling lining the lower walls) was popular in the early 1800s and had resurgence in the early 1900s. Central heating using cast-iron radiators (right of picture) eliminated the need for fireplaces in each room. This is the P.A. Williams dining room in 1919; by then, electric chandeliers had obviated the need for candles or gas fixtures. (Longmeadow Historical Society, Paesiello Emerson Collection.)

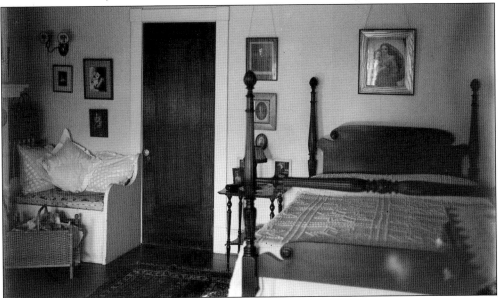

A bedroom in the P.A. Williams house concludes this interior series, although Paesiello Emerson captured several more images in 1919. The candlewick bedspread is a traditional New England design that employed the thick cotton yarn used for candlewicks as a decorative and insulating element. (Longmeadow Historical Society, Paesiello Emerson Collection.)

This is the corner of Bliss Road and Longmeadow Streets in 1914; suburban development is just beginning along Bliss Road. The house at 507 Longmeadow Street was listed in the 1910 directory as belonging to Walter Bugbee, a merchant tailor in Springfield. Today, the site is home to St. Mary's Catholic Church, constructed in 1931. (Longmeadow Historical Society, Paesiello Emerson Collection.)

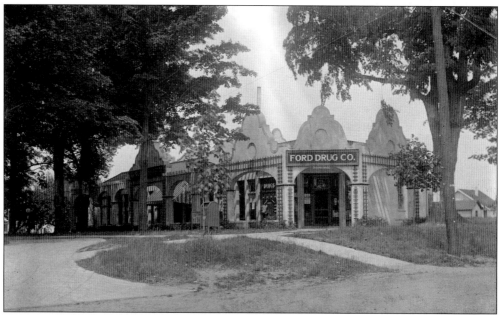

The population of Longmeadow tripled after the arrival of the streetcar, and increasing suburban development drove a need for more shops. The Colonnade was constructed around 1916 to provide retail space; by the time of this 1918 photograph, the Ford Drug Company occupied the corner shop at Bliss Road and Longmeadow Street. (Longmeadow Historical Society, Paesiello Emerson Collection.)

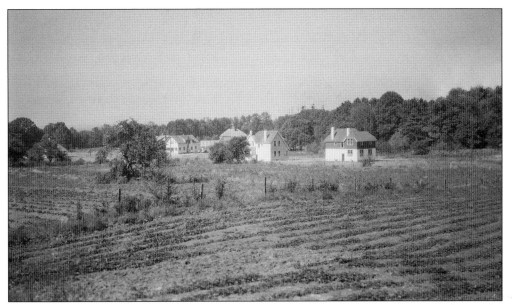

A 1912 map shows Edgewood platted but not yet built, but by 1916, houses were replacing the former farm fields originally owned by the Cooley family. (Longmeadow Historical Society, Paesiello Emerson Collection.)

Workmen are putting the final touches on a new commercial center at the corner of Longmeadow Street and Edgewood Avenue in 1916. A grocery store has already opened; no signs have been posted yet for the three stores to the north or the garage to the south. Today, a CVS pharmacy, Rinaldi's Restaurant, the Longmeadow Package Store, and Alex's Bagel Shop occupy this site. (Longmeadow Historical Society, Paesiello Emerson Collection.)

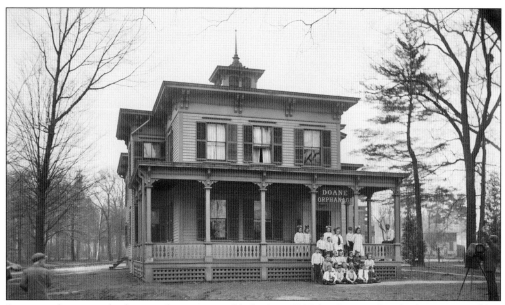

Longmeadow once had an orphanage, established in 1902 by George Sanford Doane and his wife, Lucy Maria Cook. Located at the corner of Longmeadow Street and Forest Glen Road, it was home to 24 children according to the 1910 census. This photograph was taken in April 1915. (Longmeadow Historical Society, Paesiello Emerson Collection.)

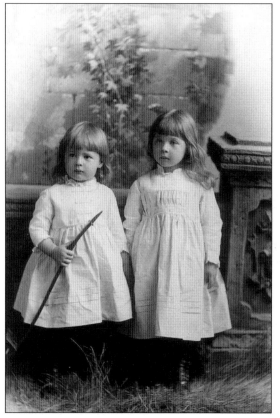

Douglas Bertram Wesson (age two) and Eleanor Sanford Wesson (age four) are pictured in 1887. They were the children of Florence May Stebbins Wesson and Joseph Hawes Wesson, a principal at the Smith & Wesson Company of Springfield, cofounded by his father, Daniel B. Wesson. Joseph Wesson purchased land on Forest Glen Road in 1907 and built homes for his three children—Eleanor, Douglas, and Victor Hawes Wesson, born in 1890. (Archives of the Wood Museum of Springfield History.)

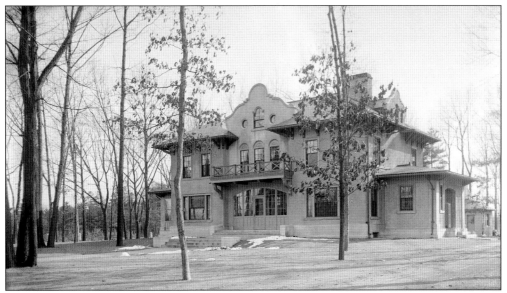

Eleanor Sanford Wesson (1883–1954) married Flynt Lincoln (1882–1946), and their family occupied this Mission Revival–style home at 161 Forest Glen Road. Flynt Lincoln and Florence Wesson, Eleanor's mother, donated the Boulder Memorial on the Longmeadow Green, dedicated in 1922 to the memory of Longmeadow residents who took part in all wars up to and including World War I. Eleanor Lincoln was involved with the Springfield Girls' Club and the Hampden County Children's Aid Association; Flynt Lincoln was president of the Springfield Boys' Club and helped the Visiting Nurses Association and the Springfield Chapter of the American Red Cross. (Longmeadow Historical Society, Paesiello Emerson Collection.)

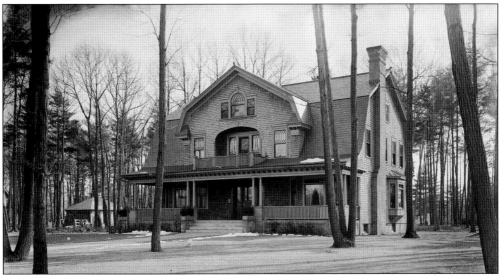

Douglas B. Wesson and Elba Cotton married in 1907 and moved into this house at 109 Forest Glen Road in 1909. D.B. Wesson was a bookkeeper at the Union Trust Company and then worked for many years at Smith & Wesson, rising to vice president of the company his grandfather cofounded. Douglas and Elba were active in the community. Douglas was president of the association planning and building the Longmeadow Community House in 1922 and later a supporter of the Longmeadow Police Benefit Association. (Longmeadow Historical Society, Paesiello Emerson Collection.)

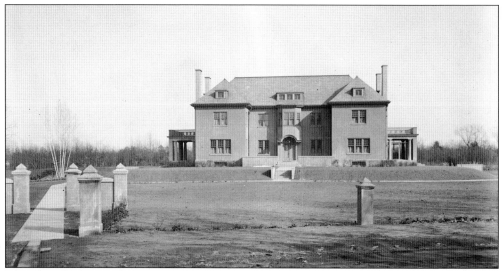

The Born house, at the corner of Forest Glen Road and Laurel Street, is pictured in 1913. Henrietta Falke Born purchased 63 acres from the heirs of Sylvester Bliss in 1910 and built her home facing Forest Park. She died at 56 in 1915, and much of the estate became the Colony Hills development, although her heirs occupied the home until 1937. While most of the grand mansions along Forest Glen Road have survived, this house at 5 Laurel Street fell victim to escalating maintenance costs and the shortage of buildable lots in contemporary Longmeadow. It was razed in the late 2000s and replaced by several new homes. (Longmeadow Historical Society, Paesiello Emerson Collection.)

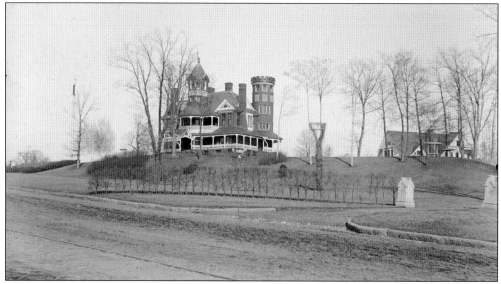

Pecousic Villa, pictured in 1907, was the home of Everett Hosmer Barney, a Civil War arms manufacturer who later became wealthy as the inventor of clamp-on ice skates and roller skates. Barney was instrumental in creating Forest Park, one of the largest municipal parks in the United States. While the land north of the Pecousic Brook, including Pecousic Villa, was in Springfield, much of the park was created with land ceded by Longmeadow. The Barney Mansion is gone, although its carriage house survives. Pecousic Brook was dammed to form Porter Lake. (Longmeadow Historical Society, Paesiello Emerson Collection.)

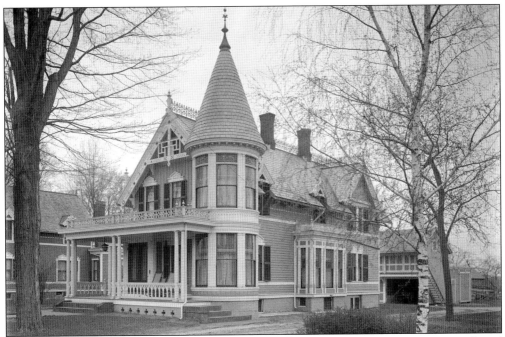

Contractor Thomas D. Watters, who built Pecousic Villa, created this striking gingerbread structure at 70 Longmeadow Street as his own home. Watters, along with his brother Joseph, built several office buildings in Springfield as well as the Barney Mansion in Forest Park. The house today looks much the same as it did for this 1910 photograph. (Longmeadow Historical Society, Paesiello Emerson Collection.)

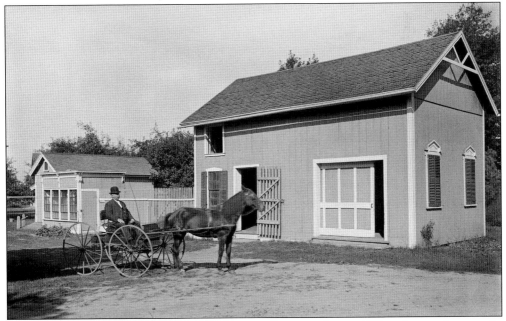

T.D. Watters also served as park commissioner in Longmeadow in 1901 and as a selectman in 1907. He is pictured in front of his shed at the rear of 70 Longmeadow Street with his horse and carriage in 1910. (Longmeadow Historical Society, Paesiello Emerson Collection.)

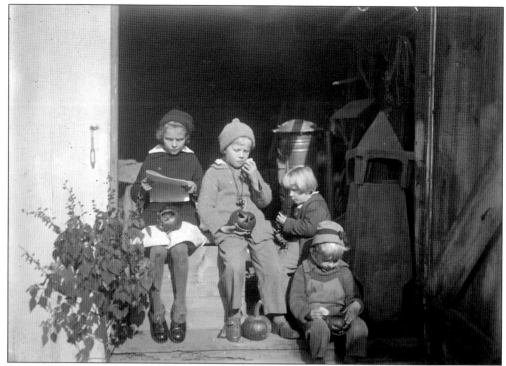

Paesiello Emerson captured the Ward family children at play in several photographs. This November 1, 1918, photograph shows them posed with jack-o'-lanterns just after Halloween. (Longmeadow Historical Society, Paesiello Emerson Collection.)

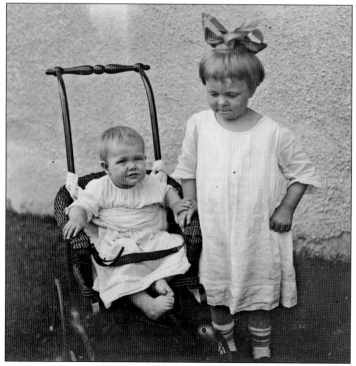

Paesiello Emerson photographed Virginia (right) and Elizabeth Tiffany in July 1919. According to the 1920 census, their father, Floyd, was employed as an auditor for a publishing company, and their mother, Belle, and grandmother Alice Monroe also lived in the home at 102 Belleclaire Avenue. (Longmeadow Historical Society, Paesiello Emerson Collection.)

Clifford S. Kempton was a prominent fruit grower whose fields were located on the east side of Longmeadow Street near Bliss Road. The family lived at 481 Longmeadow Street at the time of the 1910 census and owned the house at 384 Longmeadow Street by 1920. This family photograph dates from 1909. (Longmeadow Historical Society, Paesiello Emerson Collection.)

Photographs abound of the grand mansions on Longmeadow Street, but images of more modest structures are harder to find. The Jorey family is pictured in 1901 in front of their house at 253 Bliss Road, near the corner of what is now Laurel Street. The home, enlarged with a rear ell but shorn of its front porch, still stands. Until 1923, Laurel Street ran south only as far as Farmington Road. (Longmeadow Historical Society.)

Converse Street was (and remains) the northernmost east–west thoroughfare, with the others being Bliss Road, Williams Street, and Maple Street. This 1913 image captures the street's generous proportions at the intersection with Longmeadow Street and its streetcar tracks. Alonzo Converse (1813–1904), born in Agawam, was a riverboat pilot and senior partner in the Converse-Parker Company, which operated freight boats on the Connecticut River. His home on Converse Street included apple orchards and a cider mill. (Longmeadow Historical Society, Paesiello Emerson Collection.)

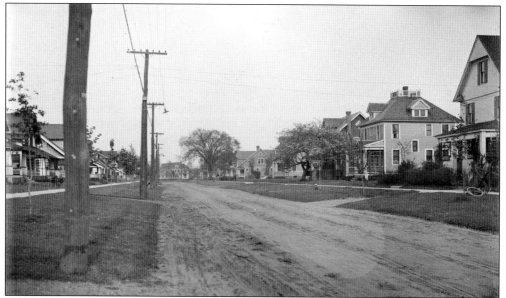

Bliss Road at the corner of Main Street is pictured in 1916. Longmeadow Street has periodically been known as Main Street and more specifically North Main Street (north of the green), South Main Street (south of the green), and East and West Main Street on either side of the green. Suburban development is already under way in this image. (Longmeadow Historical Society, Paesiello Emerson Collection.)

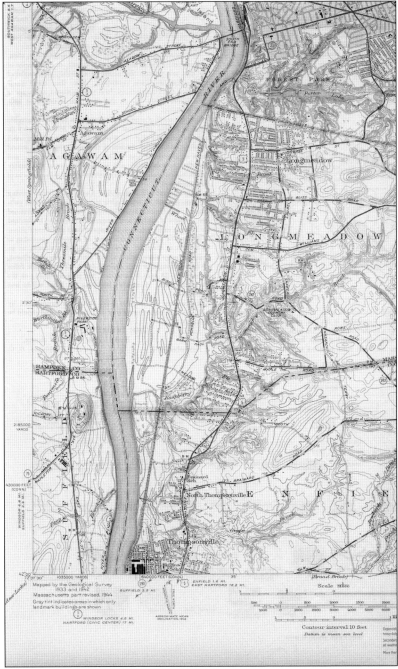

This geological survey map of 1944 shows the South Park and Colony Hills developments filled in with housing. Homes extend westward along Converse Street and Bliss Road and their parallel side streets. Laurel Street has been extended through the former town watershed at Bliss Park, and following the relocation of a house, it now provides a through connection to Shaker Road. Most of the eastern side of town is still sparsely inhabited. State Route 192 into Connecticut is designated along Mill Road (now closed) and joins Shaker Road below the pond at the Longmeadow Country Club. (Longmeadow Historical Society.)

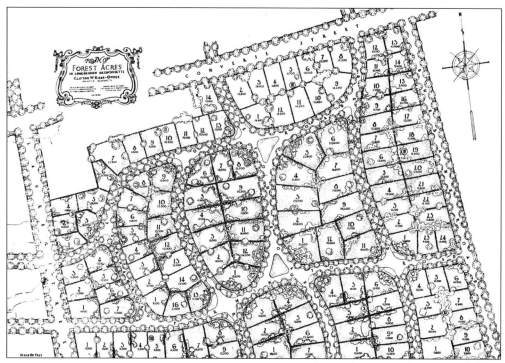

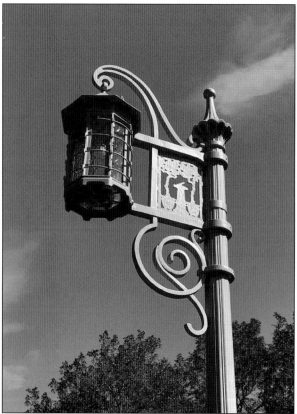

Forest Acres was the name Clifton Kibbe chose for his housing development bounded by Laurel Street to the west, Converse Street to the north, Burbank Road to the east, and Bliss Park to the south. Ellington and Farmington Roads run west to east through the development. This plan dates from 1927. Today, the area is known as the Kibbe tract. (Longmeadow Historical Society.)

The Colony Hills and Glen Arden neighborhoods were landscaped by Olmsted Brothers, established by the sons of Frederick Law Olmsted, designer of Forest Park in Springfield, Central Park in New York, and the Emerald Necklace system of parks and parkways in Boston. While the Great Depression slowed the pace of development, construction continued to add new homes to Longmeadow. Pictured here is one of the iconic streetlamps designed for the Colony Hills neighborhood. (Author's collection.)

Five

TAKING CARE OF BUSINESS

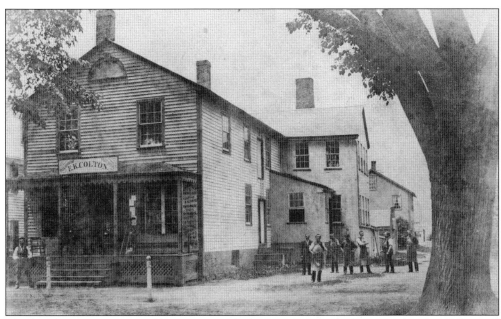

This building at 776 Longmeadow Street was built in 1805; it was the Longmeadow Post Office and also the Gold and Silver Thimble Shop between 1839 and 1848. By the time of this photograph in 1885, it had become E.K. Colton's General Store and housed the post office and part of the Newell Brothers Button Factory. Following service as a real estate office, it is now the Spa on the Green. (Longmeadow Historical Society.)

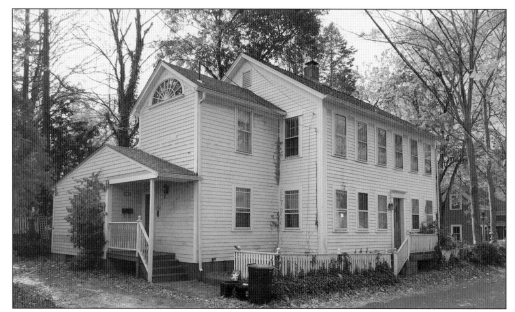

Dimond Chandler began manufacturing cloth buttons in 1840 in this house at 19 Chandler Avenue. Longmeadow natives Samuel and Nelson Newell, who had developed expertise in the textile business in Hartford and New York City, returned to their hometown in 1848 and joined the firm. The business expanded to occupy part of the Colton Store and by 1855 was producing 85 percent of the buttons in America. (Longmeadow Historical Society.)

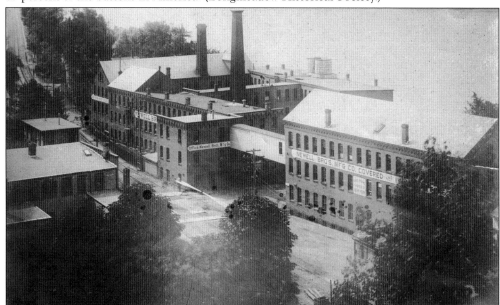

In 1860, the Newell brothers bought out Dimond Chandler's interest in the firm, which had outgrown its Longmeadow headquarters. The business relocated to Springfield in 1861, although Samuel Franklin Chandler, a relative of Dimond's, continued to produce spectacles, spoons, and watches in the Longmeadow building. Pictured here is the Newell Brothers Manufacturing Company on Howard Street in Springfield, just north of Longmeadow and situated on the Connecticut River by the New York, New Haven & Hartford Railroad tracks. (Longmeadow Historical Society.)

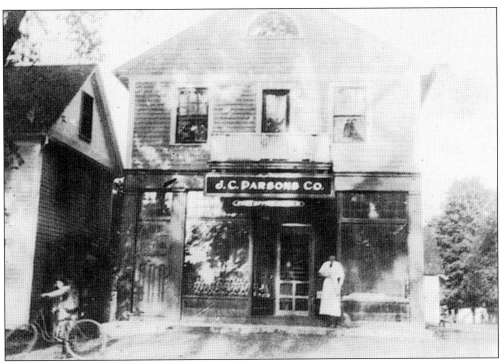

An employee at J.C. Parsons & Co. is sweeping the sidewalk outside the general store at 776 Longmeadow Street. Parsons purchased the property from the Allen estate and later sold the business to Charles Wood in 1911. The store contained a branch post office for registering letters and selling stamps. (Longmeadow Historical Society.)

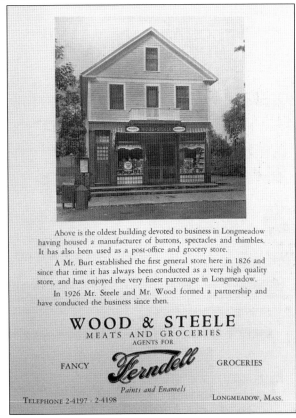

Above is the oldest building devoted to business in Longmeadow having housed a manufacturer of buttons, spectacles and thimbles. It has also been used as a post-office and grocery store.

A Mr. Burt established the first general store here in 1826 and since that time it has always been conducted as a very high quality store, and has enjoyed the very finest patronage in Longmeadow.

In 1926 Mr. Steele and Mr. Wood formed a partnership and have conducted the business since then.

WOOD & STEELE
MEATS AND GROCERIES
AGENTS FOR

FANCY *Ferndell* GROCERIES

Paints and Enamels

TELEPHONE 2-4197 - 2-4198 LONGMEADOW, MASS.

Charles Wood of Springfield purchased the Parsons store in 1911 and partnered with a Mr. Steele in 1926 to form Wood & Steele Meats and Groceries. This advertisement from 1933 highlights its claim to operating the oldest building devoted to business in Longmeadow. (Longmeadow Historical Society.)

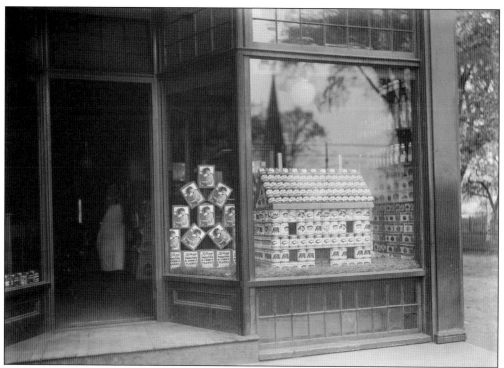

C.W. Wood's store stood at 776 Longmeadow Street, on the corner of Chandler Avenue and Longmeadow Street at the center of the green. Paesiello Emerson captured the selection of canned goods available on May 18, 1914. The steeple of the First Church is captured in the window's reflection. (Longmeadow Historical Society, Paesiello Emerson Collection.)

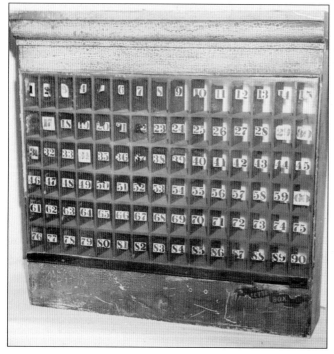

The Longmeadow Post Office was closed in 1902, but letter boxes, albeit empty, still survived at the Wood & Steele general store in 1940. (Longmeadow Historical Society.)

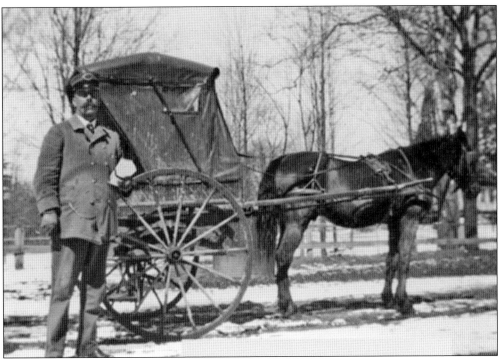

Cornelius J. Shine was the postman, photographed in 1912. Although the post office had closed in 1902, "Cornie" continued to deliver mail until 1917. He would take the streetcar to the Springfield Post Office, returning to the north end of town to deliver mail along Longmeadow Street to the state line at Enfield in his homemade chariot. Boarding the trolley again, he would pick up the afternoon mail, return to his rig, and then deliver mail northward along the Longmeadow Street. (Longmeadow Historical Society.)

The 1912 Longmeadow Business Directory included architects, carpenters, dairymen, home heating dealers, dressmakers, grocers, insurance agents, lawyers, physicians, and restaurateurs. The blacksmiths, cider manufacturers, tobacconists, ice dealers, and livery stable owners are no longer. (Longmeadow Historical Society.)

LONGMEADOW
BUSINESS DIRECTORY.

ARCHITECT.
Fay Le Vere C., Bonniewood

BLACKSMITH AND HORSE-SHOER.
Webster Nathan, Chandler n Longmeadow

BUTTER AND EGGS.
Brooks Arthur A., 107 Hopkins pl

CARPENTERS AND BUILDERS.
Quinn William J., 544 Longmeadow
Watters Joseph W., 76 Longmeadow

CIDER MFR.
Willard Samuel M., Laurel n Benedict ter

CIGARS AND TOBACCO.
Starkey John J., at state line

COAL AND WOOD DEALER.
Mason Frank E., Birnie rd

DRESSMAKER.
Goodman Mary W., 551 Longmeadow

GROCERS.
Mathews Elizabeth R. Mrs., 891 Longmeadow
Wood Charles L. 776 Longmeadow

ICE DEALER.
Allen John D., 930 Longmeadow

INSURANCE AGENTS.
Hibbard Edwin O., 539 Longmeadow
Ransehousen Herbert H., 108 S Park av

JUSTICES OF THE PEACE.
Demond Frank J., 237 Longmeadow
Emerson Willam F., 417 Longmeadow

Medlicott William B., 720 Longmeadow

LAWYERS.
Demond Frank J., 237 Longmeadow
Kaps John D., 1482 Longmeadow

LIVERY STABLE.
Mason Frank E. (boarding), Birnie rd

MARKET GARDENER.
Kempton Clifton S., 481 Longmeadow

MEAT MARKET.
Wood Charles L. 776 Longmeadow

MILK DEALERS.
Burt Harry M., 1374 Longmeadow
Crawford William J., Forest av n Taylor
Pomeroy Andrew L., 1587 Longmeadow
Radasch M. L. Mrs., 918 Longmeadow
Reedy George A., 37 Bliss

PHYSICIAN.
Martin Harry C., 20 Woodlawn pl

POULTRY RAISERS.
Burdett Charles E., Taylor n Forest av
Kempton Clifton S., 481 Longmeadow
Tabor Edward P., jr., 1607 Longmeadow
Washburn Stanley T., Bliss

RESTAURANT.
Sharkey John J. (lunch), at state line

SWEATER MFR.
Hitchcock Anna L. Mrs., 836 Longmeadow

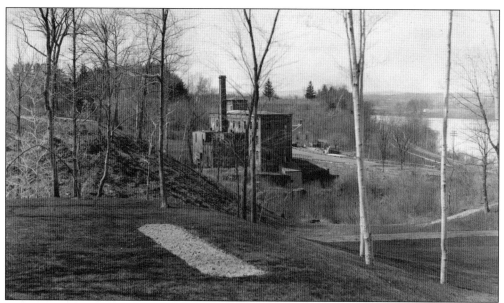

Prior to the creation of Forest Park, the northern border of Longmeadow was the Pecousic River. Beginning in the 17th century, the land bordering the Pecousic near the Longmeadow (or Pecousic) Bridge was home to many industries, from sawmills to arms manufacturers. James Warner, born in 1817, worked at the Colt firearms factory in Windsor Locks before leaving in 1850 to form his own company in Springfield. In 1857, he built this three-story brick building in then Longmeadow to take advantage of the nearby railroad track for shipping. (Archives of the Wood Museum of Springfield History.)

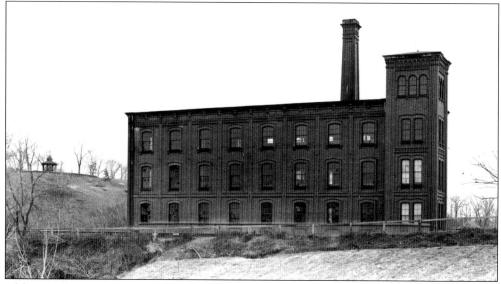

Although business boomed during the Civil War, a civilian market failed to materialize in the aftermath, and Warner closed his factory in 1867. One of his employees, E.H. Barney, had recently secured a patent for clamping ice skates to shoes, and the factory produced his skates. Barney later bought the property and built Pecousic Villa on the hill just to the east. While the old factory produced papier-mâché for a time, it was eventually torn down and the land deeded to enlarge Forest Park. (Archives of the Wood Museum of Springfield History.)

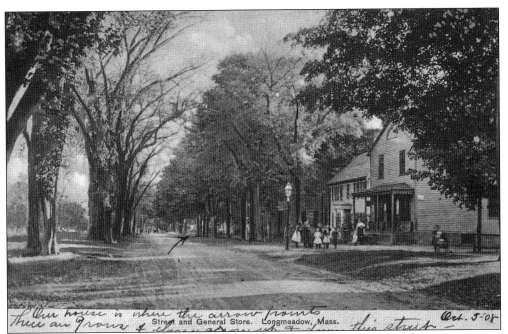

Longmeadow Street is pictured in this 1908 postcard view looking south from Chandler Avenue. The general store is on the right. The postcard writer has added, "Our house is where the arrow points. There are 9 rows of elms up and down this street." (Longmeadow Historical Society.)

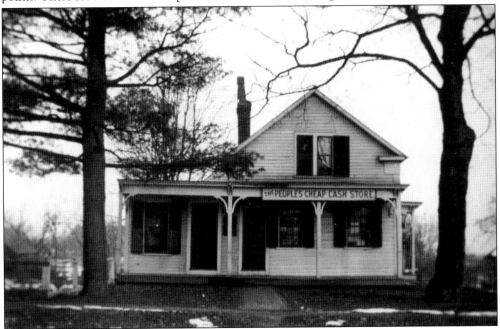

Stephen Hale likely built this home at 891 Longmeadow Street in 1831. The Longmeadow Post Office was later located here, and Albion K. Matthews was postmaster from 1885 to 1889 and again from 1893 to 1897. His wife, Elizabeth Matthews, operated the People's Cheap Cash Store. The store and post office were separate buildings according to an 1894 map, but only a single building survives today. (Longmeadow Historical Society.)

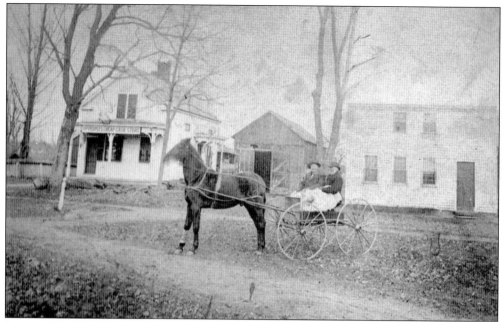

Longmeadow Street is in the foreground of this photograph along with a horse and buggy carrying two men. The People's Cheap Cash Store, its barn, and another house are in the background. Only the house on the left (the Stephen Hale House of 1831) remains today. (Longmeadow Historical Society.)

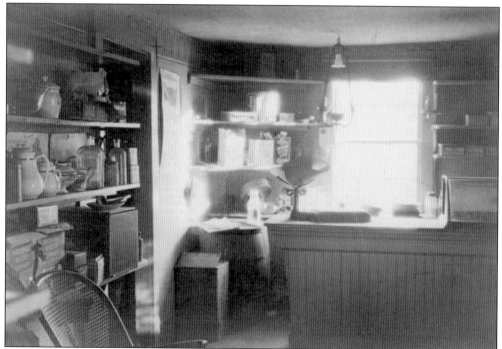

The interior of the Matthews Cash Store is pictured in 1922. Albion Matthews died in 1900; his widow, Elizabeth, sold a variety of items including thread, needles, and pins. (Longmeadow Historical Society.)

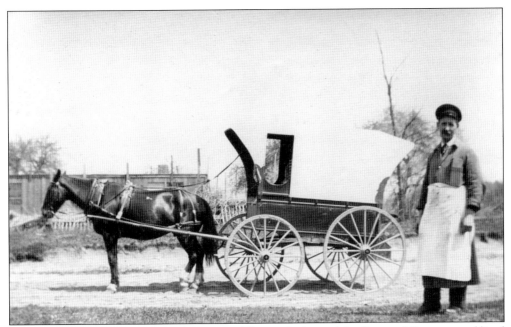

Arthur A. Brooks, best known as the meat peddler, worked out of the George Allen store and lived on Hopkins Place. He is pictured with his horse-drawn cart. This photograph will be familiar to patrons of Armata's Market, established in 1963; it is one of several historical pictures adorning the walls. (Longmeadow Historical Society.)

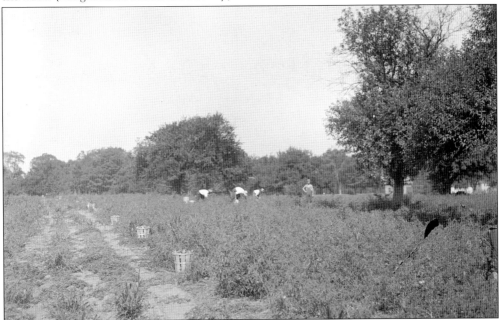

C.S. Kempton and family farmed a tract of land on the east side of Longmeadow Street near the northern edge of town. This 1908 photograph shows workers picking tomatoes. Kempton's firm was renowned for its ever-bearing strawberries, which were advertised as bearing heavily in summer and fall, even if planted as late as June. (Longmeadow Historical Society, Paesiello Emerson Collection.)

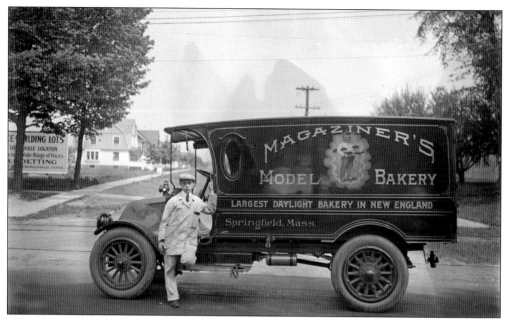

Magaziner's Model Bakery was located in Springfield but delivered to its clientele in the rapidly growing suburb by 1918. The location of this photograph is not documented but appears to be the northern end of Longmeadow Street, where "choice building lots" were being advertised. (Longmeadow Historical Society, Paesiello Emerson Collection.)

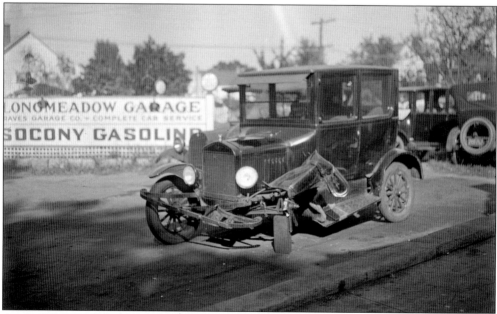

Automobiles created a new industry to fuel and repair the growing number of vehicles. Socony is an acronym for Standard Oil Company of New York, one of the spin-offs created by the 1911 antitrust agreement dismantling the original Standard Oil. Socony merged with the Vacuum Oil company (which marketed Mobilgas) and eventually became Mobil Oil, now part of ExxonMobil. The Longmeadow Garage in 1925, as now, was at 467 Longmeadow Street at the corner of Belleclaire Avenue. (Longmeadow Historical Society, Paesiello Emerson Collection.)

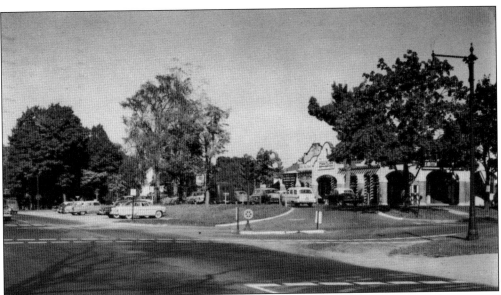

Prior to the construction of commercial areas at the Longmeadow Shops and at the junction of Shaker and Maple Roads, most commercial activity occurred on Longmeadow Street. Traffic on Route 5 delivered a steady stream of customers in the days before the interstate. This c. 1959 postcard shows the crowded parking lot at the corner of Bliss Road and Longmeadow Street. (Longmeadow Historical Society.)

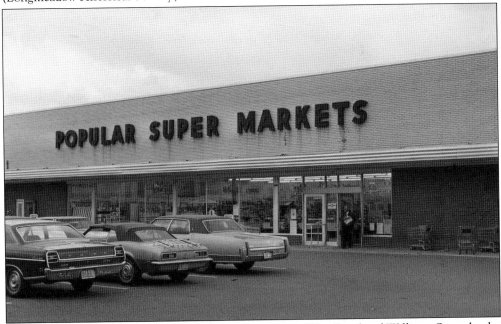

A supermarket was initially proposed at the intersection of Bliss Road and Williams Street by the Grand Union chain of New York. The zoning agreement included donation of land that became Bliss Court and the tennis courts just to the west. The store opened in 1960 as the Popular Market, part of a Springfield-Hartford area chain owned by the Block family. In 1972, two of the stores, including this Longmeadow facility, were sold to the Big Y chain. This photograph dates from 1972. (Big Y Foods.)

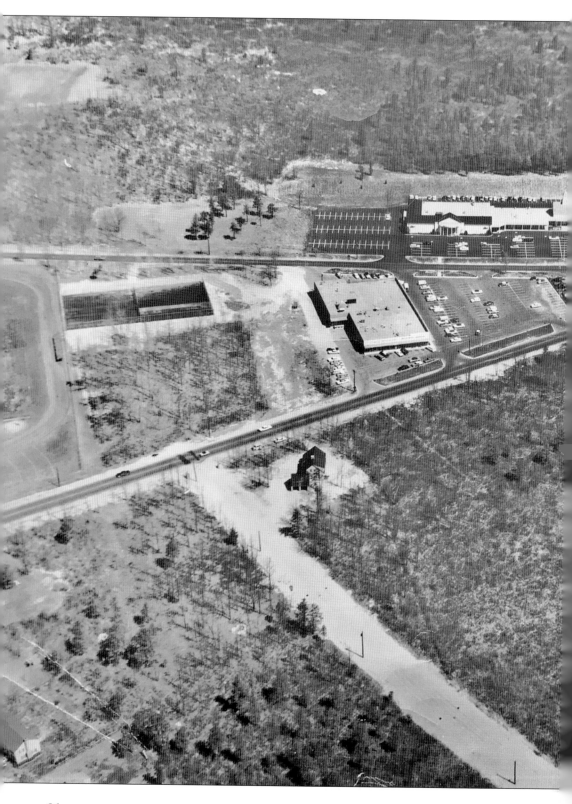

In 1955, the planning board established two new commercial zones—one at the intersection of Maple and Shaker Roads, and the other where Bliss Road forms a wye with Williams Street. As this aerial photograph demonstrates, the latter area was largely uninhabited then, although it rapidly filled in during the next decade. A single house occupies the corner of Williams Street and Captain Road. The Popular Market opened in 1960 and the Longmeadow Shops in 1962. A deserted Redfern Drive occupies the upper right corner in 1962. (Richard A. McCullough Jr.)

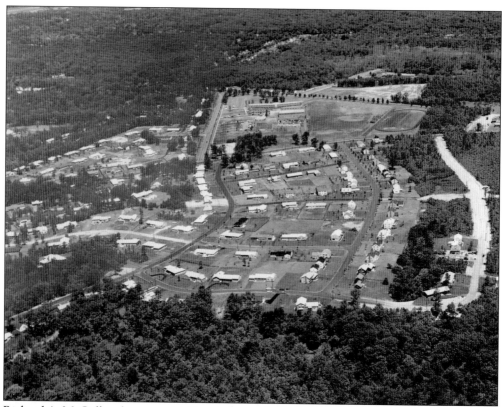

Richard A. McCullough was an Air Force pilot in the Berlin Airlift and later a commercial pilot for Trans Ocean Airlines. As a real estate developer in the late 1950s, he chose aviation-themed names for his streets. In this aerial view, Merriweather Drive snakes from the trees to the high school, Viscount Road is to the right, and Captain Road has been cleared but not yet paved. Vanguard Lane, Caravelle Drive, Primrose Drive, and Captain Road are the cross streets south of Williams Street. (Richard A. McCullough Jr.)

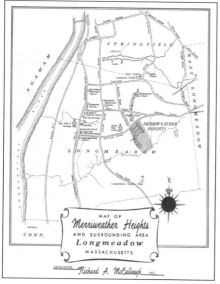

Local schools, houses of worship, and recreational facilities are highlighted in this c. 1960 promotional map. Of note, Laurel Street is shown as continuing through Forest Park and connecting with Longhill Street in Springfield. This connection did not actually exist, although Magawiska Drive connected Forest Glen Road to Washington Boulevard and Longhill Street in Springfield through the park before streets were reconfigured to allow an exit off Interstate 91. (Richard A. McCullough Jr.)

Six

HOUSES OF WORSHIP

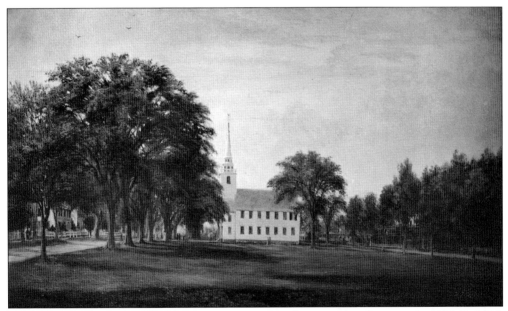

Longmeadow's first meetinghouse was constructed in the center on the green in 1716. By 1764, the small structure (32 by 38 feet) became inadequate; the second meetinghouse was constructed in 1767–1768 just north of the original church. This oil painting by William Ruthven Wheeler (1832–1894) was commissioned by Prof. Richard Salter Storrs III (1830–1884) and appears as the frontispiece of his 1883 *Proceedings at the Centennial Celebration of the Incorporation of the Town of Longmeadow.* (Longmeadow Historical Society.)

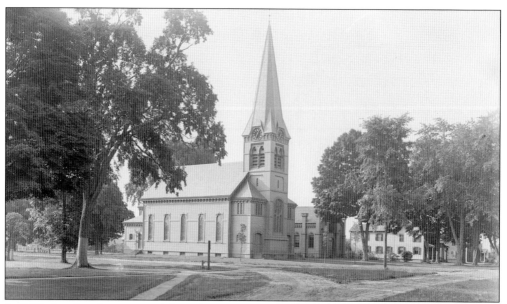

In 1874, the church was moved from the green to its present location. The remodeling included the removal of balconies, replacing the small first- and second-story windows with longer and larger windows, and a coat of brown paint. Paesiello Emerson captured the church in its Gothic incarnation in 1907. The small building south of the church was a chapel that was torn down in 1930. (Longmeadow Historical Society, Paesiello Emerson Collection.)

Rev. Stephen Williams's original home was destroyed in an 1845 fire. Several years later, the parishioners of the First Congregational Church authorized construction of a parsonage on the site of the Williams home, which housed ministers from 1857 to 1917. Later, it housed church school classes and served as a residence for church caretakers. In 1921, the parsonage was moved south to the other side of the First Church to accommodate construction of the Longmeadow Community House. It is now home to the Longmeadow Montessori School. (Longmeadow Historical Society, Paesiello Emerson Collection.)

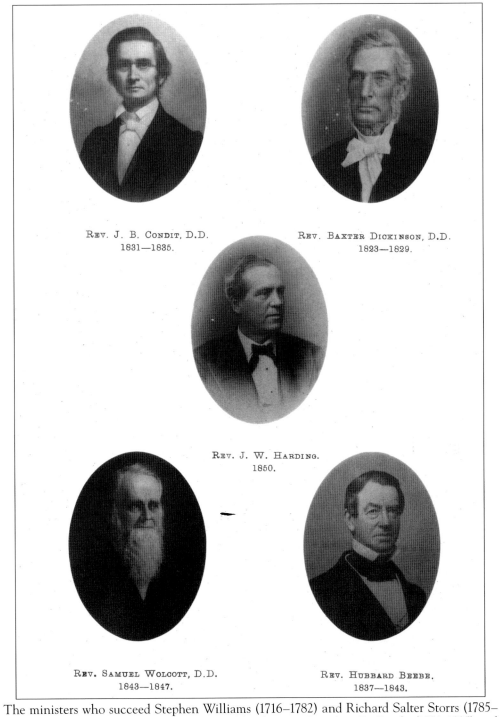

REV. J. B. CONDIT, D.D.
1831—1835.

REV. BAXTER DICKINSON, D.D.
1823—1829.

REV. J. W. HARDING.
1850.

REV. SAMUEL WOLCOTT, D.D.
1843—1847.

REV. HUBBARD BEEBE.
1837—1843.

The ministers who succeed Stephen Williams (1716–1782) and Richard Salter Storrs (1785–1819) were celebrated in the 1883 centennial book. Revs. Jonathan B. Condit (1831–1835) and Baxter Dickinson (1823–1829) are in the top row; Samuel Wolcott (1843–1847) and Hubbard Beebe (1837–1843) in the bottom row, and John William Harding (1850–1891) is in the center. (Longmeadow Historical Society.)

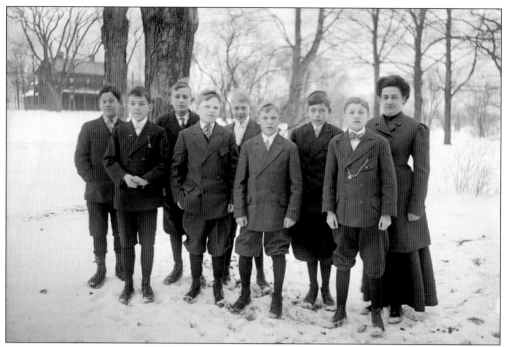

Sunday schools in the United States often took the form of an hour or more of Bible study and instruction in Christian doctrine. Although adult education may have been offered, more typically instruction was focused on children, with classes held before, during, or after a church service. This 1910 photograph shows a Longmeadow Sunday school class; it is believed that the teacher on the right is named Jessie Garner. (Longmeadow Historical Society, Paesiello Emerson Collection.)

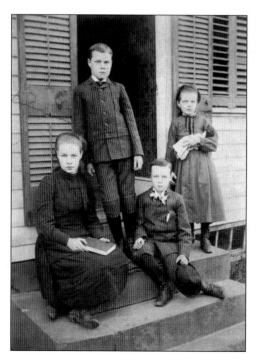

The Colton children are dressed in their Sunday finest in this 1892 photograph. From left to right are Endora Reynolds Colton, Francis Parmalee Colton, Albert Newton Colton, and Margaret Emily Colton. Their parents were Emily Reynolds, born 1874 in Enfield, and Longmeadow native John Newton Colton (1837–1899), who was the eighth-generation descendant of Quartermaster George Colton, one of the original settlers. (Longmeadow Historical Society.)

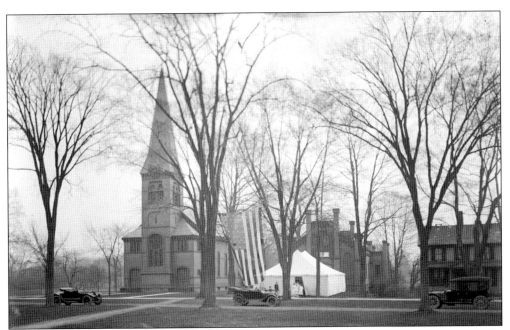

The First Church, a tent, and the chapel are shown in 1913. The chapel, built in 1854, originally occupied the site of the church and was used for Sunday school, social activities, and Pilgrim fellowship groups. This chapel was first moved south to allow the relocation of the church from the green and then again across Williams Street behind the Longmeadow Community House. It was demolished when the new town hall was built in 1930. (Longmeadow Historical Society, Paesiello Emerson Collection.)

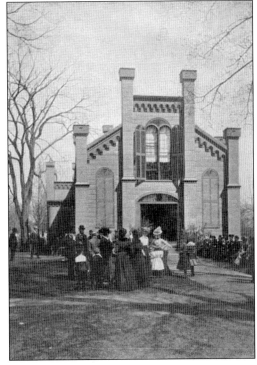

The first May Breakfast, held in 1869, was a fundraiser for the First Church to purchase a piano. Over time, May Breakfasts became one of the largest events in western Massachusetts. By the 1870s, townspeople would arise at 5:00 a.m. to prepare meals and bring them to the event. Originally, food was served continuously from 6:00 a.m. to 3:30 p.m.; during later years, the schedule migrated to later in the day and became two sittings—lunch and supper. Pictured here is the May 1901 event in front of the chapel on the green. The last May Breakfast occurred in 1970, but the tradition has recently been revived after a 46-year hiatus. (Longmeadow Historical Society.)

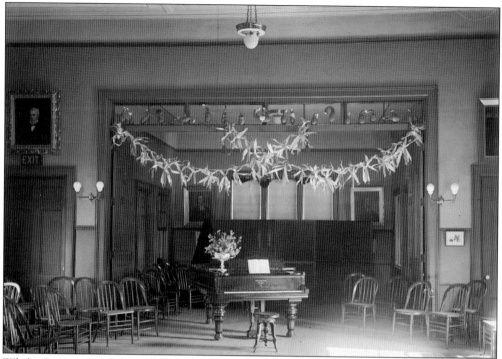

While the May Breakfast celebrated the start of another growing season, the Harvest Supper celebrated fall. Shown here is the interior of the chapel decorated for the 1916 Harvest Supper. (Longmeadow Historical Society, Paesiello Emerson Collection.)

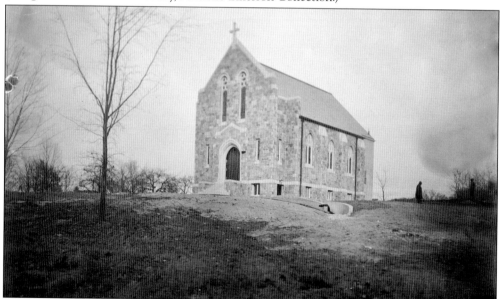

Episcopalians in Longmeadow initially traveled to Springfield to worship until St. Andrew's Mission Church was established in 1921 in a storefront at the corner of Longmeadow Street and Edgewood Avenue. Land was acquired in 1923 to build a new church, shown here in 1925. A substantial addition to St. Andrew's was completed in 1963. (Longmeadow Historical Society, Paesiello Emerson Collection.)

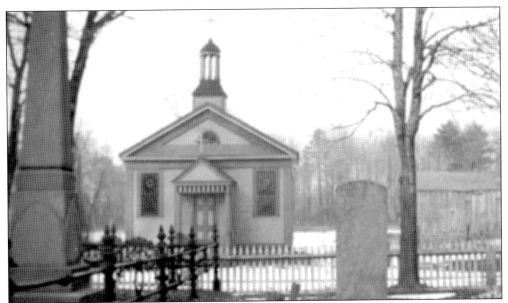

Five men purchased a former spectacle shop on the green and organized St. Mary's Parish in 1868. The building was moved to Williams Street opposite the Longmeadow Cemetery and dedicated on October 2, 1870. The parish later purchased land at the corner of Bliss Road and Longmeadow Street, moved to a temporary structure in 1924 and dedicated its current building on Christmas Eve 1931. (Longmeadow Historical Society.)

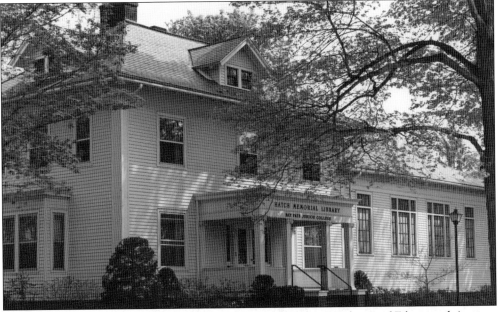

The First Church of Christ, Scientist began using the former residence of Edwin and Augusta Hibbard at 539 Longmeadow Street for church services in 1924. By 1928, a spacious meeting room was added to the south side of the house. The building was purchased by Bay Path Junior College in 1961 and is now the school's Hatch Library. The First Church of Christ, Scientist constructed a new church on Williams Street at Redfern Drive in 1962 but recently sold that building; services are again held on the Bay Path campus. (Longmeadow Historical Society.)

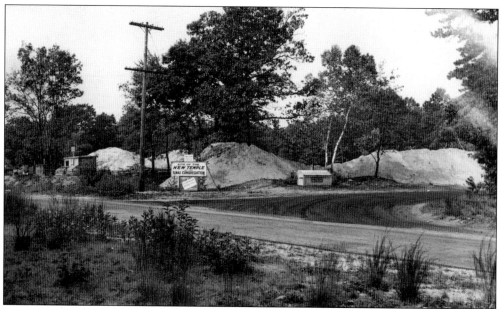

Sinai Temple, founded in 1931, was the first Reform congregation in the Springfield area. Having outgrown its original home in a former mansion at 188 Sumner Avenue in Springfield, the congregation purchased land in the late 1940s on Dickinson Street just south of Pecousic Brook. The temple is technically in Springfield, while the adjoining Jewish Community Center straddles the Longmeadow-Springfield border. (Sinai Temple of Springfield.)

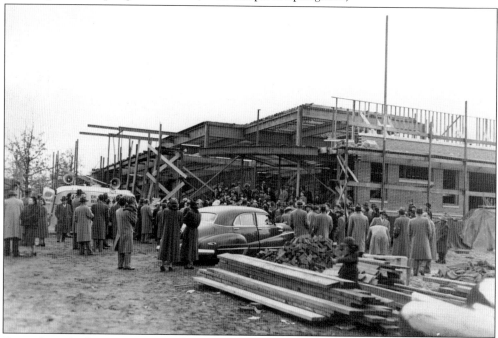

Ground was broken for the new Sinai Temple on August 15, 1949. Pictured is the cornerstone ceremony, held on November 11, 1949. The left side of the building is parallel to Dickinson Street, and the right side is parallel to Porter Lake Drive. Note the public address truck amplifying the proceedings. (Sinai Temple of Springfield, photograph by Kenneth Wax.)

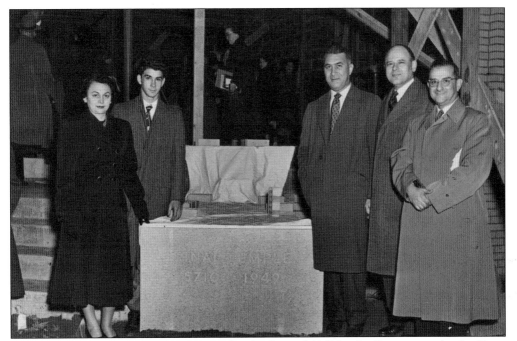

The cornerstone is dated 5710 in the Jewish calendar and 1949 by the Gregorian calendar. From left to right are Lillian Klempner, sisterhood president; Larry Satell, representing the youth group; Abraham Simons, brotherhood president; Rabbi Herman Eliot Snyder; and Monte Feinstein, temple president. (Sinai Temple of Springfield, photograph by Kenneth Wax.)

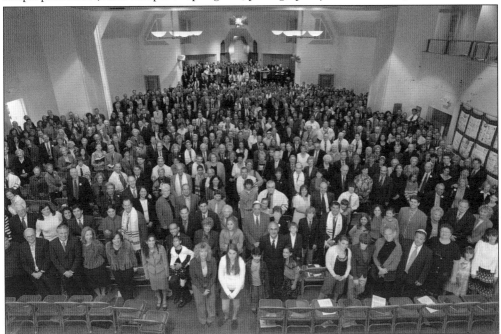

Sinai Temple celebrated its 75th anniversary in 2006. The entire congregation gathered in the sanctuary and auditorium for this photograph by Michael Gordon of the *Springfield Republican* newspaper on Yom Kippur morning, October 2, 2006. (Sinai Temple of Springfield.)

Longmeadow's first cemetery, laid out in 1702–1703, was a one-acre strip bordering today's Williams Street leading east out of town. The earliest burials were at the eastern end. Sometime after 1788, the town leased the westernmost portion of today's burying ground, where a blacksmith and wheelwright's shop sat. The cemetery expanded east and south over the next 100 years, leaving the corner of Williams and Longmeadow Streets available to the First Church as a site for the chapel building and eventually for the church. Pictured is the inner, oldest portion of the cemetery in October 1912. Headstones and footstones were originally aligned facing east, in accordance with tradition. In 1868, a beautification project removed or buried footstones, leveled the ground, and repositioned all headstones facing north. (Longmeadow Historical Society, Paesiello Emerson Collection.)

The Longmeadow Cemetery Association was formed in 1872 to offer burial plots within the same enclosing fence as the burying ground but under separate control. These later stones, pictured in 1912, are properly aligned on an east–west axis. The Longmeadow Historical Society hosts a Ghosts in the Graveyard event every October where local actors portray the long-since deceased. (Longmeadow Historical Society, Paesiello Emerson Collection.)

Seven

SCHOOLS AND COLLEGES

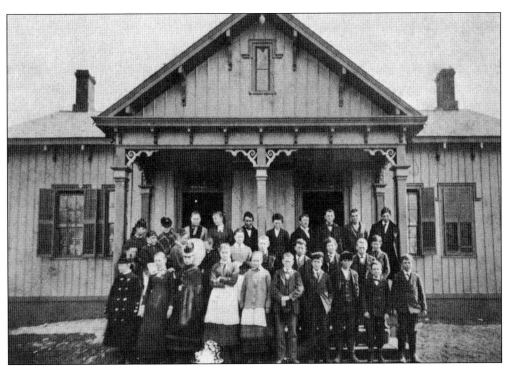

Longmeadow's first schoolhouse was built in 1717 and located on the green somewhat south of the meetinghouse, also then on the green. The school burned to the ground around 1853 and was replaced by a larger wooden structure (pictured) on the site of today's Center School. With population growth, two other schools were built, and this became known as the District 1 schoolhouse. (Longmeadow Historical Society.)

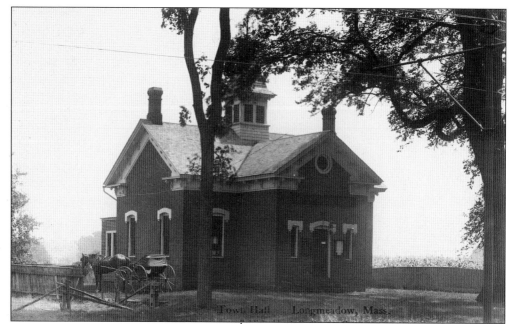

The District 2 schoolhouse was also known as the old North School. Built in 1855, it served students north of Wheelmeadow Brook. In 1906, it gained a second life as the town hall and police station. In 1930, it transitioned yet again to become the Albert T. Wood Post 175 of the American Legion. In addition to the three districts serving today's Longmeadow, the town in the 19th century operated five additional districts in East Longmeadow. (Longmeadow Historical Society.)

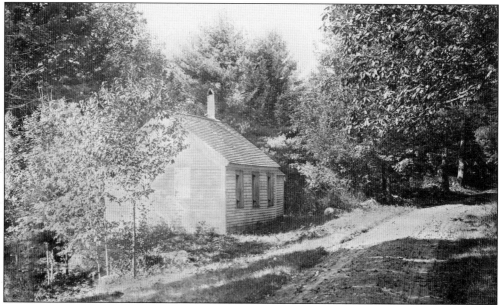

District 3 served students south of Longmeadow Brook in this wooden structure on Longmeadow Street south of Kingsbury Place. As early as 1856, the teacher was lauded by the school committee for "much skill and ingenuity" in her efforts. Known as the "Little Red Schoolhouse," the facility closed in 1893, and students relocated to the Center School. This photograph dates from 1906. (Longmeadow Historical Society, Paesiello Emerson Collection.)

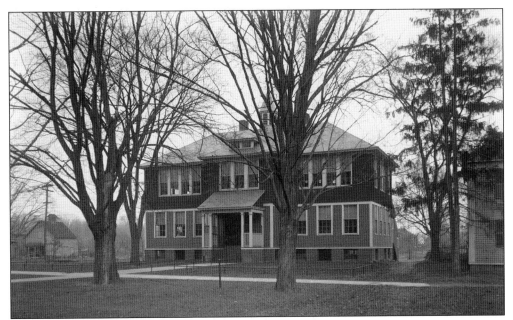

In 1899, a larger, more modern Center School was built to augment the former two-room structure. The new building, pictured in 1918, was used for grades one to nine. Both buildings were removed in 1929 to provide space for today's Center School. (Longmeadow Historical Society, Paesiello Emerson Collection.)

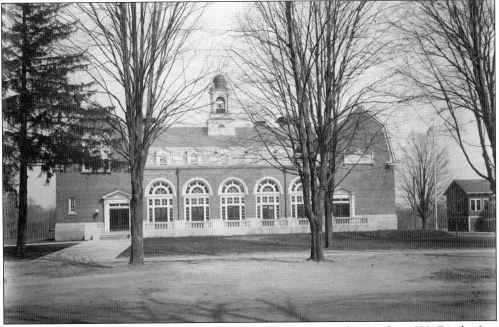

A separate junior high school was authorized by voters in 1920 and opened in 1922. For the first time, students could enjoy a lunchroom and a gymnasium. Previously, students had travelled home for lunch. The high school opened in 1955; before then, students travelled to Springfield, with tuition and trolley fare paid by the town. (Longmeadow Historical Society, Paesiello Emerson Collection.)

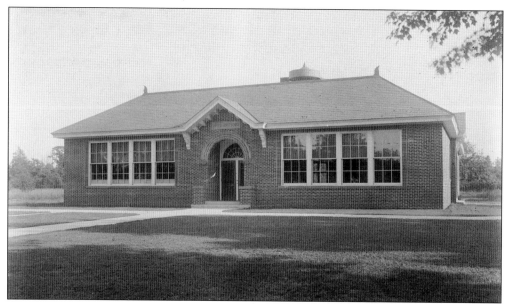

Between 1910 and 1920, Longmeadow was adding some 150 residents per year, including many families attracted to the new suburban developments. The Converse Street School opened in 1916 to serve the northern edge of town; the architecturally similar Norway Street Elementary School opened the same year. The Converse school closed in 1982 and was converted to condominiums. (Longmeadow Historical Society, Paesiello Emerson Collection.)

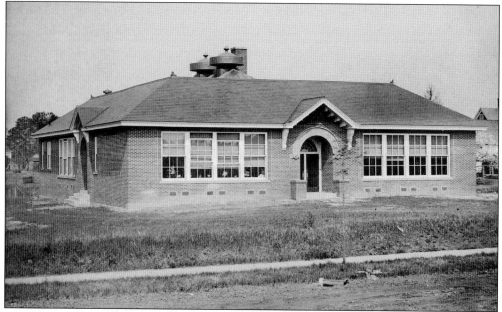

The Norway Street Elementary School (pictured in 1918) was the successor to the District 3 school, serving the southern part of town. It was replaced by the Greenwood Park School in 1966. The Willie Ross School for the Deaf was founded in 1967 following a rubella epidemic that left many children hard of hearing. The innovative day school, founded when residential placement of deaf children was the norm, occupies the former Norway Street Elementary School building. (Longmeadow Historical Society.)

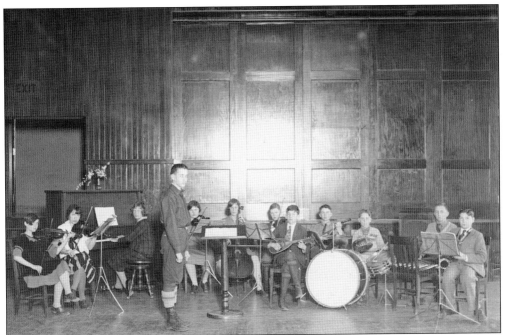

Longmeadow's music program includes an orchestra, a concert band and wind ensemble, a jazz band, a pep band, and men's and several women's choirs. During the 35-year career of Michael Mucci, Longmeadow High School music department chairman, the National Association of Recording Arts and Sciences awarded three Grammy Signature Awards to the school. Shown here is a school band performing at the Longmeadow Community House in 1911. (Longmeadow Historical Society.)

With the onset of the baby boom after World War II, yet more classroom space was needed. Wolf Swamp School opened in 1956, followed by Blueberry Hill School in 1957, Williams School in 1960, and finally Glenbrook Middle School in 1968. A group of not-quite boomers poses for a first-grade assembly picture in Linda Pratt's classroom in 1950. (Longmeadow Historical Society.)

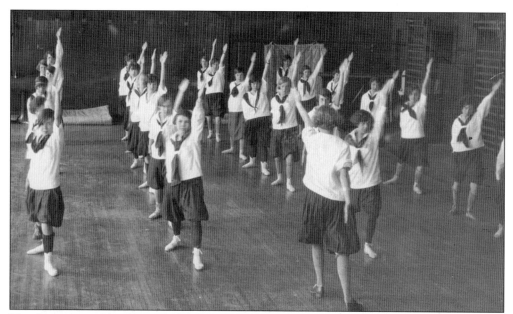

The first private school to include physical education as part of the curriculum was the Round Hill School in Northampton, Massachusetts, in 1823. Emigrants from England, Sweden, and Germany may have influenced physical education, especially the German Turner Societies that stressed gymnastics. However, until the 1920s, physical education was rarely mandated as part of the curriculum, and early schools lacked gymnasia. This c. 1920 photograph shows Longmeadow girls participating in exercises at the Center School. (Longmeadow Historical Society.)

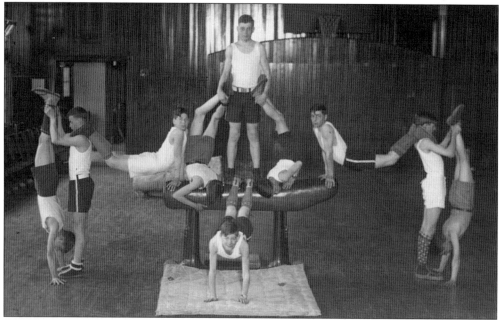

Gymnastics were a prominent component of physical education, as demonstrated by Longmeadow boys in the gym around 1920. As befits a town adjoining the birthplace of basketball, a hoop and backboard can be seen, although the floor lacks formal court markings. (Longmeadow Historical Society.)

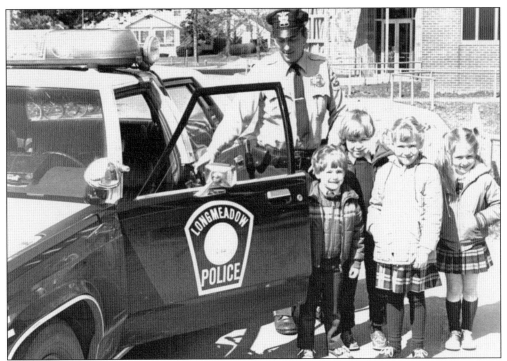

Private and parochial schools have long been available as alternatives to the town schools—in the latter half of the 19th century, at least four private schools existed. St. Mary's opened its parochial school in 1967, followed by the Lubavitcher Yeshiva Academy in 1979 and Heritage Academy in 1982. Longmeadow police officer (and future chief) Richard Marchese is pictured with students outside St. Mary's School around 1983. (Longmeadow Police Department, photograph by Ken Anderson.)

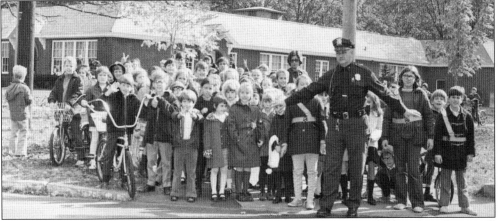

Walking or biking to school has become increasingly difficult in urban communities but is still very much cherished in Longmeadow, even in 2017. Safety officer Edward Rich ensures safe passage for Converse Street School students at the corner of Laurel Street in the early 1980s. Converse Street is named after Alonzo Converse (1813–1904), a riverboat pilot and eventually senior partner in the Converse-Parker Company providing freight service on the Connecticut River. After the railroads replaced commerce on the river, Alonzo ran a cider mill east of Laurel Street on land that was originally the Cooley apple orchards. (Longmeadow Police Department.)

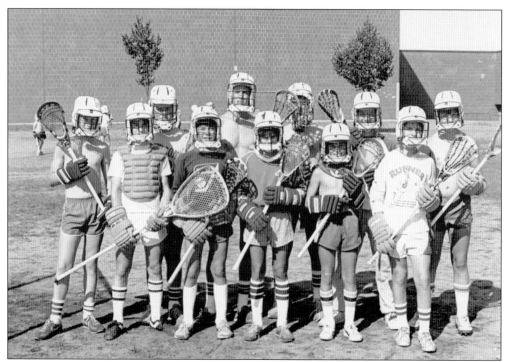

The Longmeadow High School boys' lacrosse team is pictured in 1983. Longmeadow's lacrosse program has been highly successful, winning 18 Massachusetts state championships since 1970. The program has produced a number of All-American selections, and many alumni have played for top collegiate programs. Longmeadow's tennis, ice hockey, girls' soccer and volleyball, boys' basketball, football, and golf teams have all won championships. (Longmeadow Historical Society, photograph by Ken Anderson.)

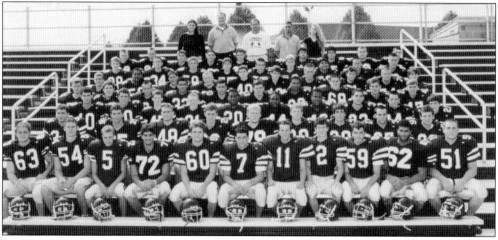

Longmeadow High School played its first football game in October 1956. By 1958, the Lancers had their first undefeated season, presaging great success in the 1960s, a 28-2 record between 1984 and 1986, and a 184-39 record and 11 "Super Bowl" titles between 1993 and 2012 when Alex Rotsko was head football coach. The 2003 team (and its coaches, pictured here) went 12-0 to become AA conference and "Super Bowl" champions for the second year in a row. (Author's collection, photograph by Pierre Catellier.)

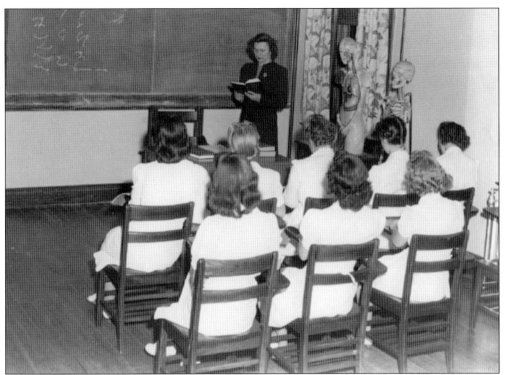

The Bay Path Institute was founded in 1897 as a coeducational business school in Springfield. With women playing an increasing role in business during World War II, the school changed its focus to educating them, moved to Longmeadow in 1945, and occupied the former Wallace estate at 588 Longmeadow Street. Future medical secretaries are learning shorthand and anatomy in this 1949 image. (Bay Path University.)

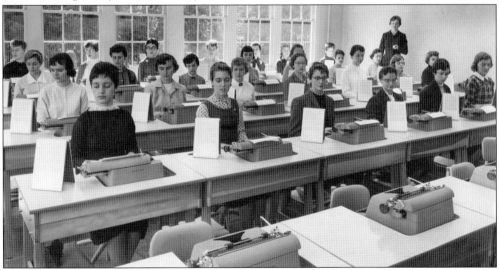

As career options opened up for women, Bay Path steadily increased its educational offerings. Typing skills were still part of the core curriculum when this photograph was taken in Glen Hall in 1959. In 1988, the school became Bay Path College, and it became Bay Path University in 2014. (Bay Path University.)

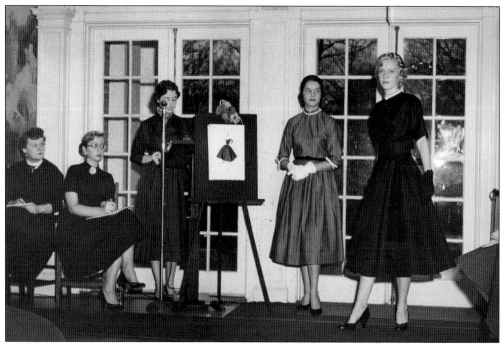

Fashion design was among the course offerings in 1953. From left to right, two unidentified judges are taking notes, student commentator Phyllis Vincent of Pittsfield is at the microphone, Nancy Lane of Wethersfield, Connecticut, is assisting, and Norma Fischer of East Longmeadow is modeling the black afternoon dress shown in the drawing. (Bay Path University.)

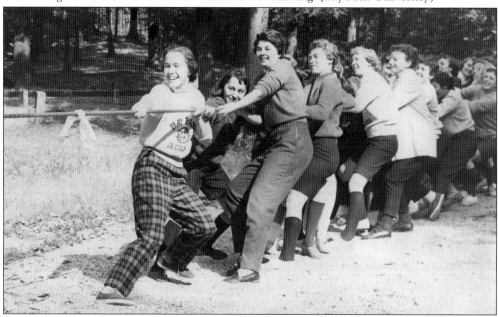

Initially a commuter school, Bay Path opened its first residence hall in 1947. Student activities included an outing club, an annual President's Tea, and school picnics. The classes of 1971 and 1972 participated in tug-of-war; the archives do not indicate which class triumphed. (Bay Path University.)

Eight

SERVING THE COMMUNITY

Towns need a place to conduct business. The 1853 chapel of the First Church, the largest place where citizens could assemble, was used for town meetings until the Longmeadow Community House was built. Longmeadow's first purpose-built town hall became East Longmeadow's in 1894 when the towns split. Shortly thereafter, the former District 2 school (built in 1855) became the town hall, police department, jail, and polling place. (Longmeadow Historical Society, Paesiello Emerson Collection.)

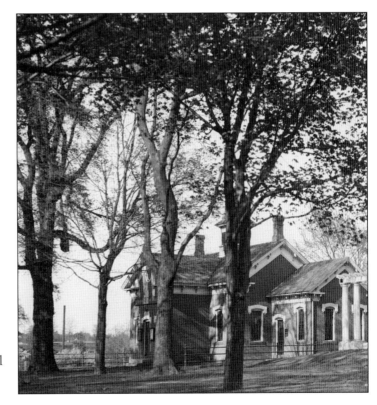

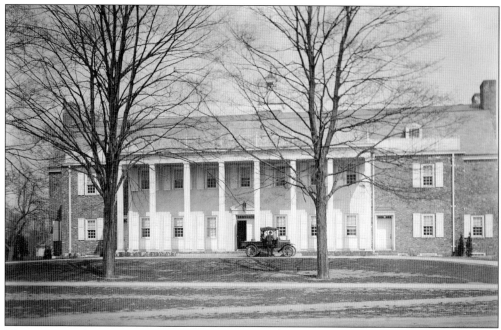

The Longmeadow Community House, built and photographed in 1923, occupies the site of the original parsonage built by minister Stephen Williams. It was funded by a bequest to the First Church from Emerett Colton (1833–1917) and purchased by the town in 1927. Old-timers recall seeing movies for a nickel, and today, the hall serves a variety of purposes, including as the polling place for town and national elections. (Longmeadow Historical Society, Paesiello Emerson Collection.)

Longmeadow's town government consists of a select board with five members elected by the town. This photograph, from the 1933 sesquicentennial book, features, from left to right, Frank E. Smith (town clerk, treasurer and collector of taxes), Percival Sinclair (superintendent of public works), John D. Kaps (town solicitor), and Selectmen Frank B. Allen, Edwin S. Munson (chairman), and Charles H. Bump. (Longmeadow Historical Society.)

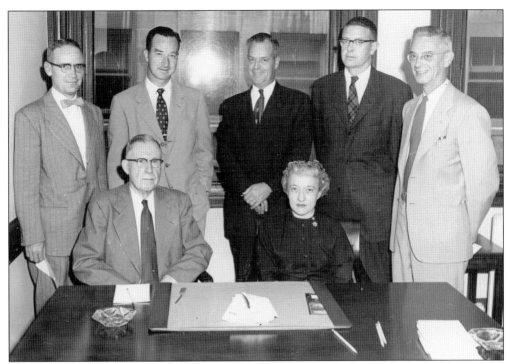

This 1953 photograph commemorates approval of a $1.375 million bond issue for construction of the town's first high school. From left to right are (seated) Frank E. Smith, town clerk, and Oma Turner, school committee; (standing) Selectman J. Bushnell Richardson Jr., Building Committee chairman Albert E. Mayer Jr., Selectmen Colin O. Cathrew and Mack F. Wallace, and school superintendent Howard Herrschaft. (Longmeadow Historical Society.)

Longmeadow residents relied on wells to supply water until population growth and public health concerns mandated a public water supply by the late 1800s. In 1894, the town issued bonds for a waterworks, followed three years later by funding for a sewer system. Watershed land along Cooley Brook east of Longmeadow Street was purchased and a water plant and standpipe (water tower) constructed. The 88,000-gallon tank atop a 70-foot trestle is visible behind St. Andrew's Church. Longmeadow began using the Springfield water supply in 1922, and the standpipe was finally demolished 14 years later. The land along Cooley Brook became Laurel Park and Bliss Park. Bliss Pool was built to replace the old town beach at the pump. (Longmeadow Historical Society.)

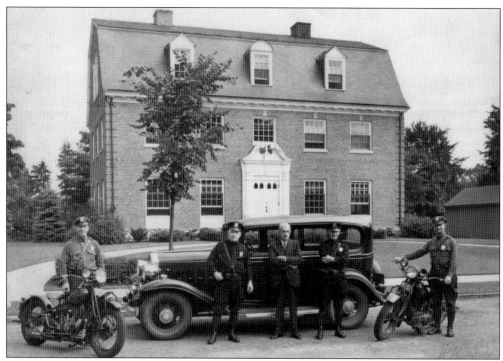

The Longmeadow Police Department was created in 1918 with Richard Warme as its first chief, along with nine police officers. The department poses for a picture for the 1933 sesquicentennial book. From left to right are H.A. Mackay, John W. Keith, Chief John F. Henderson, J.H. Gamble, and George U. Van Train. The town hall behind them, built in 1930, was modeled after the Samuel "Marchant" Colton house. (Longmeadow Police Department.)

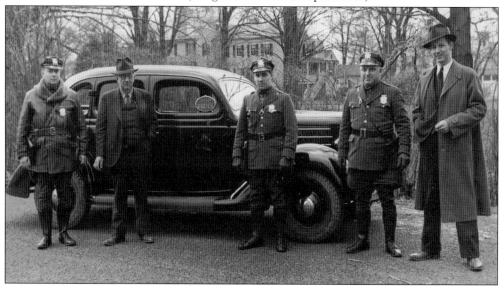

This undated photograph from the late 1930s pictures the same officers as in the previous picture. Chief Henderson (second from left) died in 1939 and was succeeded by George Van Train. A direct phone line to the station was installed in 1941; the number (7-3311) is still in use today, albeit with additional digits (413-567-3311). (Longmeadow Police Department.)

The Longmeadow Police Department purchased its first motorcycle for traffic enforcement in 1924. Ofc. John Barkman is featured in this advertisement for Indian Motocycles (as spelled by the manufacturer), which were built in Springfield from 1901 to 1953. The Chief was manufactured from 1922 until the company's bankruptcy in 1953. (Longmeadow Police Department.)

Ride the motorcycle of the year . . . the new Chief from Matchless/Indian!

Among the many improvements included in this year's Chief are a redesigned crankshaft assuring superior engine balance . . . better engine breathing plus a large capacity generator. Fun to own and fun to ride, the Chief is the perfect road machine in every way. Always a top performer, it provides riding and seating comfort that is a pleasure for those long trips. It is available with an excellent dual saddle as standard equipment or a brand new solo saddle with sprung seatpost and footboards as optional accessories.

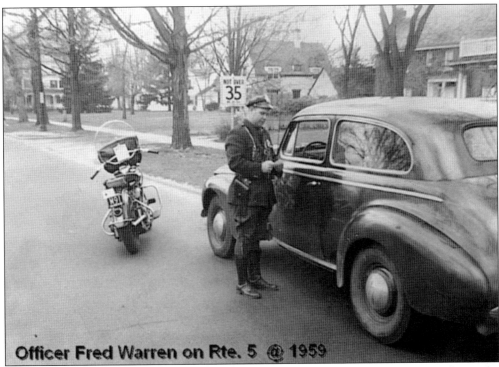

Officer Fred Warren on Rte. 5 @ 1959

Before Interstate 91 provided a high-speed bypass, Longmeadow Street (US Route 5) was the major highway route between Springfield, Hartford, and New Haven. A speed limit of 35 miles per hour was enforced. Ofc. Fred Warren is discussing the matter with a driver in 1959. (Longmeadow Police Department.)

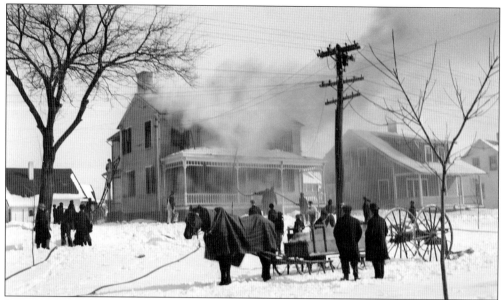

Longmeadow began constructing water mains through the town around 1900 to supplant wells and provide fire protection. The first fire apparatus was a hose reel, visible behind the horse-drawn sleigh in this March 1916 photograph. The fire destroyed the house at 50 Bliss Road owned by the Patrick family. Originally, the house stood at the corner of Bliss Road and Longmeadow Street; it was turned and moved a short distance down Bliss Road to permit construction of the Colonnade shopping center. (Longmeadow Historical Society, Paesiello Emerson Collection.)

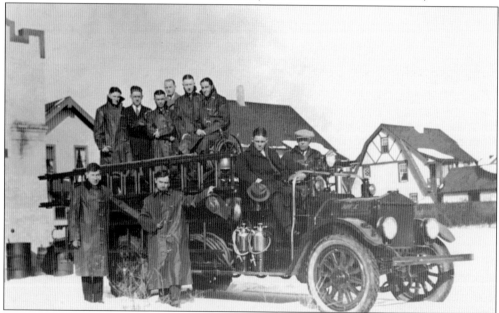

Longmeadow's volunteer fire department, pictured here, was formally established in June 1923. The town purchased a combination chemical and hose wagon, and a motor pumper and a driver were available 24 hours a day to respond to emergencies. Previously, volunteers had simply gathered one of the seven hose reels distributed about the town and hauled it to the fire. One of the hose reels has been preserved and is displayed at the fire department. (Longmeadow Historical Society.)

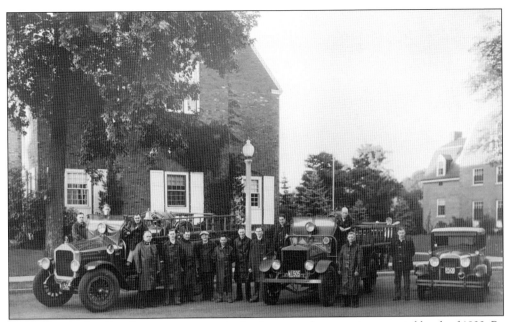

The Longmeadow Fire Department poses in the Longmeadow sesquicentennial book of 1933. By then, the department included Chief Robert Breck, Deputy Chief Everett Felton, Capt. Donald Keith, and 15 enginemen. The newer truck, a Maxim Motors triple combination pumper, was purchased in 1925. (Longmeadow Historical Society.)

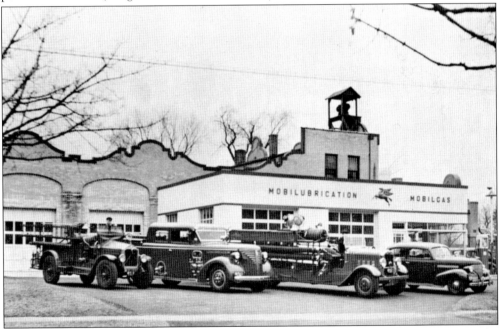

The first fire station was at the corner of Longmeadow Street and Belleclaire Avenue in the Longmeadow (Graves) Garage. A siren was installed in 1926 on the roof of the building and used codes to designate where fire response was needed. In 1960, the fire department moved to the newly constructed Public Safety Complex on Williams Street, and it has since moved next door to a state-of-the-art facility. (Longmeadow Fire Department.)

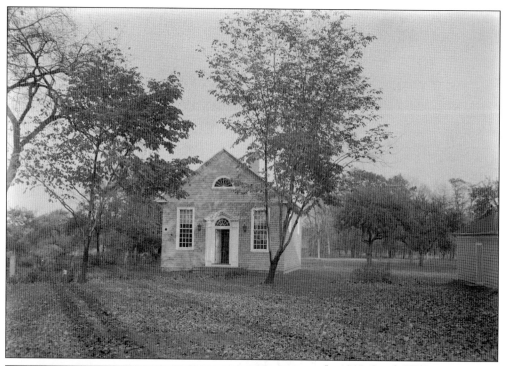

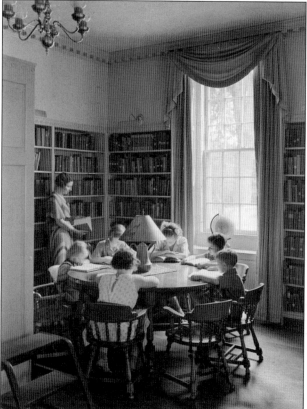

In 1907, Sarah Williams Storrs, a descendent of Rev. Richard Storrs, provided in her will a bequest of $5,000 to the library association. The will stipulated a like sum be raised to maintain a free public library in Longmeadow. The first library, pictured here, was constructed behind the Storrs house in 1911. (Longmeadow Historical Society.)

The current Storrs Library was built in 1933; it honors three generations of the Storrs family—the second minister of the First Church, his son, and two grandsons. The original Storrs parsonage was moved several yards south on Longmeadow Street to accommodate the new facility. Children are absorbed in their books in this 1936 photograph. (Storrs Library.)

Nine

LONGMEADOW
ORGANIZATIONS AND
EVENTS

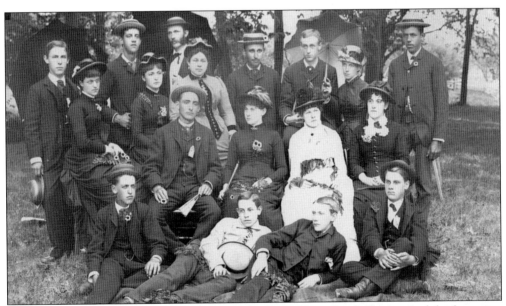

Unitarian minister Edward Everett Hale's 1870 book *Ten Times One Is Ten* inspired the formation of the TTT movement, later renamed the Lend A Hand Society. TTT reflected the power of recruiting volunteers for charitable missions, including the Boston Floating Hospital for sick children, missionary work, and a book mission that continues today. The Longmeadow chapter is pictured in June 1884. (Longmeadow Historical Society.)

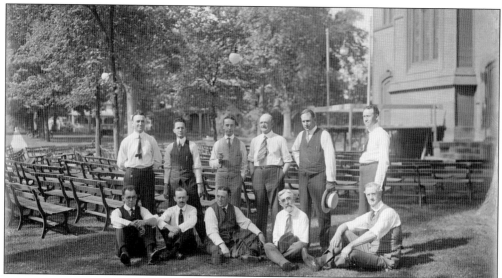

Although the United States initially avoided the conflict, it entered World War I in April 1917 after German submarine attacks on seven US merchant ships. The War Chest Rally Committee is pictured on May 20, 1918; its goal was fundraising for war relief agencies. The Great War ended a few months later on November 11, 1918. (Longmeadow Historical Society.)

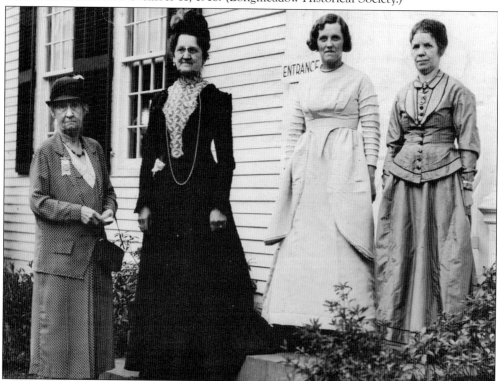

Longmeadow celebrated its sesquicentennial in 1933 with parades, speeches, and a Boy Scout jamboree on the green. Edgar Holmes Plummer authored an official souvenir booklet. Pictured on October 14, 1933, outside the Storrs Museum are (left to right) Mrs. D.T. Smith, Bertha Stuckert, Mrs. Edward J. Cordis, and Mrs. George Goodman. (Longmeadow Historical Society.)

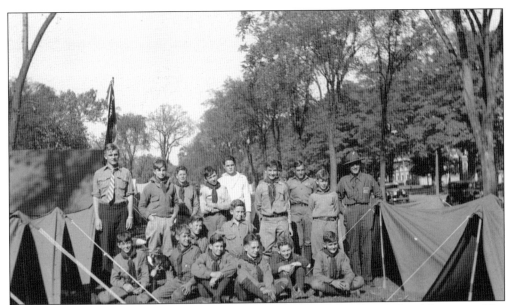

Boy Scouts established an encampment on the green during the 1933 celebrations. The photographer was Stewart Giles. Other photographs from the celebration document a parade with Cub Scouts marching, a brass band, and a man riding an old-fashioned bicycle. (Longmeadow Historical Society.)

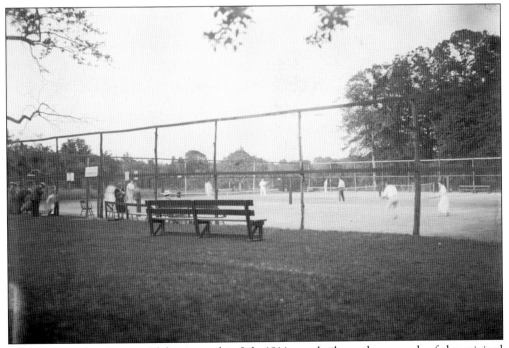

The Longmeadow Tennis Club, pictured in July 1914, was built on the grounds of the original Storrs Library; opening day was June 28, 1913. These courts were displaced by construction of the Richard Salter Storrs Library in 1933. Town courts are now located at Bliss Court near the high school. (Longmeadow Historical Society, Paesiello Emerson Collection.)

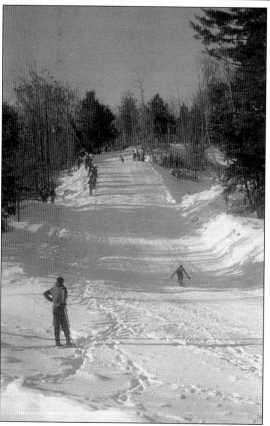

Ely Road runs west from Longmeadow Street just above the north end of the green and then north to better negotiate the steep bluff heading into the meadows. It parallels Interstate 91 and intersects Emerson Road (the former Depot Road) just before Emerson passes under the highway. Paesiello Emerson captured this winter scene on February 18, 1909. (Longmeadow Historical Society, Paesiello Emerson Collection.)

Longmeadow will never be mistaken for the White Mountains, but there is a sufficient grade between Longmeadow Street and the meadows to permit skiing. According to the 1947–1948 *Skier's Guide to New England*, the facility, just north of the green and west of Longmeadow Street, featured a ski tow, lighted at night, and had beginner, medium, and steep runs. This color postcard dates from the pre–zip code era, probably the late 1950s. (Author's collection.)

Fanny Adele Stebbins was the supervisor of elementary school science for the Springfield School Department. In 1912, together with Grace Pettis Johnson, the director of the Springfield Museum of Natural History, she organized amateur naturalists as the Allen Bird Club, naming it after Springfield native Dr. Joel A. Allen, curator of birds at the American Museum of Natural History. In 1951, the Allen Bird Club purchased 175 acres in Longmeadow as a bird sanctuary and named it after Stebbins, who had died in 1949. (Archives of the Wood Museum of Springfield History.)

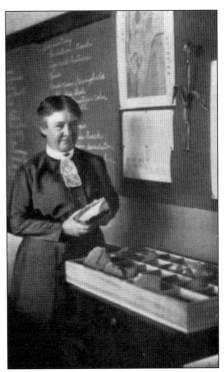

The Allen Bird Club established the Fannie Stebbins Wildlife Refuge in 1951. Bird-watchers, hikers, and photographers enjoy this rare floodplain habitat, which harbors numerous rare plant and animal species on its 330 acres. This aerial view was captured in October 2017. The sharp curve of Longmeadow Street and the Greenwood Park fields are visible at the bottom of the picture; the preserve hugs the Connecticut River, with the Six Flags park visible to the left and downtown Springfield in the upper right. (Author's collection.)

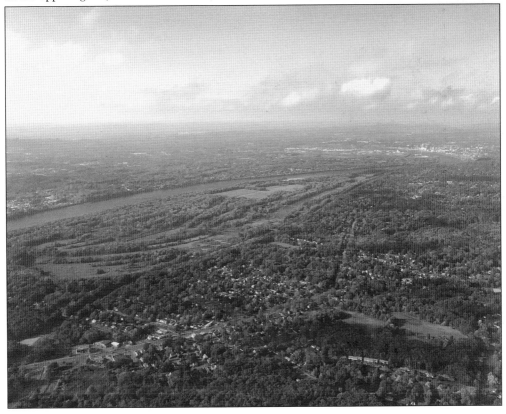

The Turnverein was a German American social and physical fitness club founded in 1855. By the late 1880s, the organization owned a building on State Street in Springfield and recreation land on today's Turner Pond in Longmeadow. Pictured in this view looking east around 1941 is Williams Street, prior to its later suburban development; the entrance to Turner Park would be on the right beyond the parked automobile. (Longmeadow Police Department, Alfred Geoffion Collection.)

Westphalia, Germany, native Eugene Joseph Kreiner and his wife, Frieda, purchased the chalet at the Turnverein social club in 1927 and renamed it the Turner Park Hofbrau. Gene, who led sing-alongs in authentic Bavarian garb, is pictured relaxing with unidentified customers. (Longmeadow Historical Society.)

The Turner Park Hofbrau was run like a big-city nightclub and became a major local attraction with live music as well as food and drink. This 1940 menu lists blue plate specials starting at 50¢, lobster for $1.10, and beer for 25¢. Jacob Ruppert beer and ale were featured. (Longmeadow Police Department.)

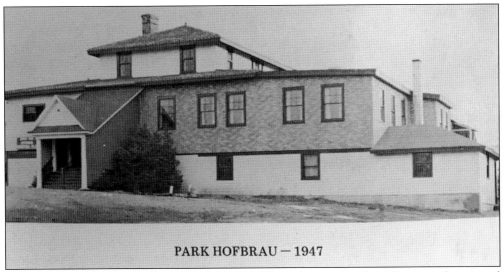

PARK HOFBRAU — 1947

The Turner Park Hofbrau is shown in early 1947, following considerable additions to the original chalet on the pond. A spectacular fire destroyed the restaurant on March 23, 1947; the building was fully involved by the time firefighting efforts began, and with no fire hydrants in the area, water was pumped from the pond until bullheads clogged the hoses. (Longmeadow Police Department.)

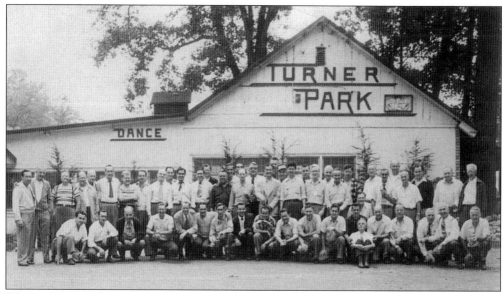

While zoning regulations prevented the main building from being rebuilt, the restaurant and snack bar stayed in business until 1968, when the town purchased the land. This undated photograph shows a group assembled for one of the many picnics and cookouts that took place. (Longmeadow Police Department.)

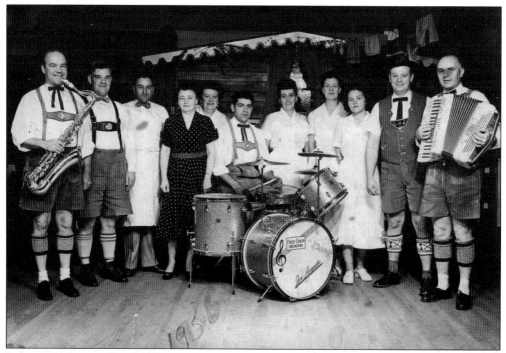

Entertainment continued at Turner Park even after the devastating 1947 fire. This photograph of employees in 1956 highlights the wait staff and the Fred Childs orchestra. Today, very few traces remain of the Turner Park Hofbrau, although a careful observer can discover the regularly spaced stones that supported buildings in the meadow just north of the pond. (Longmeadow Police Department.)

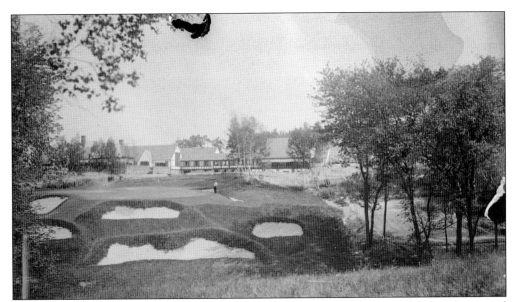

The clubhouse of the Longmeadow Country Club (LCC) is visible just beyond the sand traps and green in this 1924 photograph. The LCC was organized in 1922, and the course was designed by the renowned Donald Ross of Dornoch, Scotland. (Longmeadow Historical Society, Paesiello Emerson Collection.)

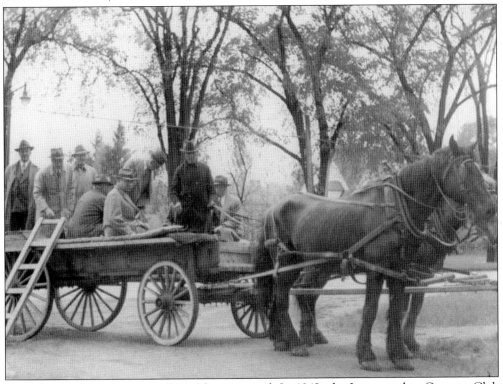

Wartime gasoline rationing affected leisure travel. In 1942, the Longmeadow Country Club inaugurated a horse-drawn cart service to ferry members to the club from the transit stop at Longmeadow Street and Mill Road. (Longmeadow Country Club.)

Endorsement arrangements between sports celebrities and manufacturers are common today; one of the first occurred between A.G. Spaulding Company and golfer Robert Tyre "Bobby" Jones (right), shown in 1931. Milton B. Reach (left), representing Spaulding, was one of the 10 founding members of the LCC and held numerous patents on sports equipment. Jones (1902–1971), a lawyer and an amateur golfer, was the first to win all four major championships (the Grand Slam) in 1930. Jones founded and helped design the Augusta National Golf Club, cofounded the Masters Tournament, and is considered one of golf's greatest players. Although he lived in Atlanta, he was a member of the LCC and summered with his family in Westfield, Massachusetts. (Longmeadow Country Club.)

The LCC had a long-standing relationship with the A.G. Spaulding Company in Chicopee. From left to right in 1932–1933 are LCC member Arthur Bassett; catcher Mickey "Black Mike" Cochrane of the Philadelphia Athletics; Milton B. Reach of Spaulding, who developed the "cushion cork" baseball in 1925; and George "Moose" Earnshaw, also of the Philadelphia Athletics, the World Series champions in 1929 and 1930. The golf outing celebrated Spaulding's signing of the two baseball greats to endorsement contracts. (Longmeadow Country Club.)

In 1983, Longmeadow celebrated the 200th anniversary of the town's separation from Springfield to become an independent community. As Longmeadow was the first town created in Massachusetts following the Revolutionary War, a reenactment of fighting between the British Redcoats and American Patriots was staged on the green. (Longmeadow Historical Society.)

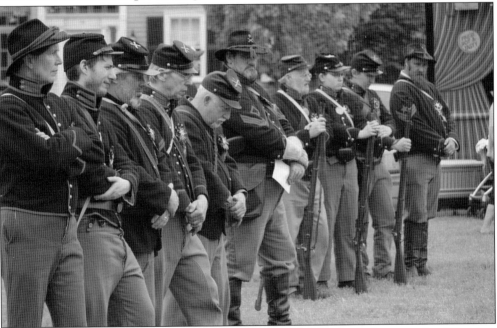

The tradition of Long Meddowe Days began in 1980. Sponsored by the Longmeadow Historical Society as an annual fundraising event, the community arts and crafts festival also features a parade and historical reenactments. This Civil War reenactment from 2014 features, from left to right, Ellie Hutchinson, Alex Colombrito, Tony Ascolillo, Brad Warren, Andy Phillips, Holland Jenkins, Carl Hutchinson, Megan Bell, Jesse Warren, and Chris Geiser. (Longmeadow Historical Society.)